The Campus History Series

CHRISTOPHER

NEWPORT UNIVERSITY

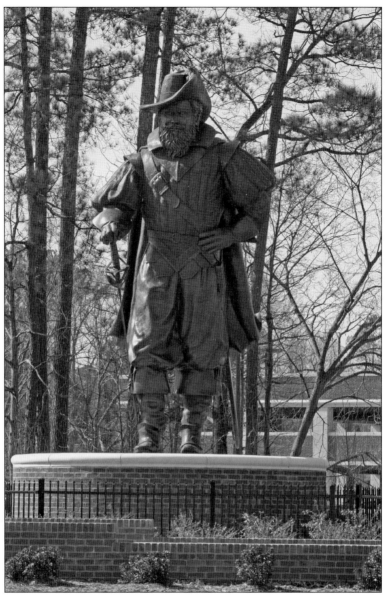

Christopher Newport University derives its name from Capt. Christopher Newport, a 17th-century English mariner and explorer. Captain Newport was a leader in the May 1607 founding of Jamestown. To honor him, the university installed this 24-foot-tall bronze statue at its main entrance in June 2007, donated by Irwin Belk of Charlotte, North Carolina, and created by renowned sculptor Jon Hair. (Photograph by John Kelly, courtesy of Christopher Newport University.)

ON THE COVER: The women's basketball team has enjoyed a long and successful history at Christopher Newport University, accumulating 24 winning seasons and 26 seasons with at least 10 wins as of 2007. Under its current head coach, Carolyn Hunter, the team has made several post-season appearances and has also played in the NCAA Tournament. Shown here is the inaugural team from the 1971–1972 season, led by coach Mary Lu Royall. (Courtesy of Christopher Newport University.)

The Campus History Series

CHRISTOPHER
NEWPORT UNIVERSITY

SEAN M. HEUVEL

ARCADIA
PUBLISHING

Published by Arcadia Publishing
Charleston SC, Chicago IL, Portsmouth NH, San Francisco CA

Printed in the United States of America

Library of Congress Catalog Card Number: 2008937775

For all general information contact Arcadia Publishing at:
Telephone 843-853-2070
Fax 843-853-0044
E-mail sales@arcadiapublishing.com
For customer service and orders:
Toll-Free 1-888-313-2665

Visit us on the Internet at www.arcadiapublishing.com

To the late H. Westcott Cunningham,
Christopher Newport University's first president,
and the late Harrol A. Brauer Jr., its first rector,
in gratitude for their work in helping
to build the vibrant institution we know today.

CONTENTS

ACKNOWLEDGMENTS

As Christopher Newport University (CNU) approaches its 50th anniversary, it has been a privilege to chronicle the story of this young and thriving institution. Further, this book would not have been possible without the generous assistance of several individuals. The Honorable Paul S. Trible Jr., Cynthia Perry, Judy Ford Wason, and Dr. Robert E. Colvin all provided the early support and encouragement necessary for this project. Also, Cecil Cary Cunningham, Dr. James C. Windsor, Dr. John E. Anderson Jr., Dr. Anthony R. Santoro, Rosemary Trible, Prof. L. Barron Wood, Dr. Rita Hubbard, Dr. Phillip Hamilton, Dr. Mario Mazzarella, Dr. George Webb, C. J. Woollum, Wayne Block, William L. Brauer, Laura Reid, Margaret Yancey, and Harry Wason each supplied extensive historical materials and information, including some of the images in this book.

Unless otherwise noted, the majority of the photographs for this project came from CNU's archives, and the university has my thanks for allowing access to these important resources. Staff members in the Office of University Relations and the Trible Library, including Bruce Bronstein, John Kelly, Caitlin Dana, Sharon Whitfield, and Amy Boykin, were particularly helpful in directing me to the items I needed to examine. I am also grateful to the editors and staff of the *Daily Press*, especially Dennis Tennant, for permitting the use of several original photographs in this book.

I further wish to thank Jennifer Green, Lisa Heuvel, and Lee Cabot Walker, who assisted me with the often-daunting tasks of photograph scanning and editing, and Warren Higgs, who provided critical scanning equipment and other historical materials. I am also grateful to my parents and extended family for their enthusiasm and support. Finally, to my wife, Katey, thank you for your love and encouragement, not just on this project, but in everything.

INTRODUCTION

Few higher education institutions have seen such rapid development as Christopher Newport University (CNU). Named for the English mariner who helped establish Jamestown in 1607, CNU evolved in less than 50 years from a small, local college to a respected senior institution in Virginia's higher education system. First located in a donated public school building, the campus now has first-rate academic and residential facilities, as well as a world-class performing arts center. While continuing its original charge of educating Virginia Peninsula residents, CNU now draws students from all over the commonwealth and beyond.

However, this young university's evolution has not always been an easy one, due to challenges ranging from budget shortfalls to political battles. Nevertheless, dedicated work by generations of students, faculty, alumni, and staff, along with friends from the outside community, has kept Christopher Newport University moving forward. This book tells their story.

CNU can trace its origins to a group of late-1950s Tidewater Virginia businessmen who were interested in enhancing the region's higher education system. Booming population growth and consolidation of localities prompted many civic leaders to reevaluate the region's educational infrastructure. In 1958, the Norfolk Junior Chamber of Commerce and interested citizens throughout Hampton Roads requested that the then-U.S. Office of Education analyze the area's higher educational needs. The office's 1959 report noted the region's increasing number of college-bound students and recommended that the Commonwealth of Virginia create a new two-year college in the North Hampton Roads area (the Peninsula) as a feeder school for the College of William and Mary in Williamsburg.

Delegate Lewis A. McMurran Jr. lobbied successfully to locate the new college in his native Newport News, supported by businessman E. J. "King" Meehan and others who wanted such an institution in that area. As an influential member of the Virginia House of Delegates, McMurran later sponsored the bill authorizing the establishment of the proposed "two-year division of William and Mary at Newport News" in the 1960 General Assembly session. Although the City of Hampton also placed a bid for the new college, Newport News officials sealed the deal when they donated the old John W. Daniel School in downtown Newport News for use as a temporary site. Further, they agreed to supply land for a permanent campus at a later date.

Meanwhile, William and Mary officials began preparing budget estimates to open the two-year branch in September 1961. They appointed William and Mary's dean of admissions and student aid, H. Westcott Cunningham, as the college's first director (and later first president) on September 15, 1960. Around the same time, William and Mary's board of visitors adopted

"Christopher Newport College" as the institution's permanent name. A group of officials, including Cunningham and McMurran, chose the name to honor Captain Newport's Peninsula ties and for his role as Virginia's "true founder."

Christopher Newport College (CNC) opened formally on September 18, 1961, in the old Daniel school with eight full-time faculty members and about 170 students. On that day, President Cunningham later recalled "hearing that bell ring at ten to eight on a Thursday morning and having chills go up and down my spine, thinking 'a college is born.' " As students attended classes, Cunningham and his staff scrounged for library books, furniture, and other supplies from whatever sources possible. They also began seeking appropriations to start building on the permanent campus site known as the "Shoe Lane tract," a stretch of land in central Newport News.

Although the new college's presence on that largely residential site was somewhat controversial, construction began in December 1963. At the time, student enrollment surpassed 600 students. On the Shoe Lane property, Christopher Newport Hall opened on September 1, 1964. Thereafter, students had to shuttle between the Daniel school and the new campus until Gosnold Hall was completed in February 1966. The campus-building boom continued into the early 1970s with the construction of Ratcliffe Gym (1967), the Captain John Smith Library (1968), Wingfield Hall (1970), and the Student Center (1973).

President Cunningham also led the young college's transition from two-year to four-year status in the late 1960s, a pivotal moment in its history. With the student body exceeding 1,000, both campus officials and community residents sought a more comprehensive academic curriculum. They argued that Christopher Newport could be best utilized by serving local youth and adult learners, allowing the Williamsburg campus to maintain its focus as a national university. Although William and Mary president Davis Y. Paschall expressed concerns regarding the young college's readiness for this step, he was a steadfast supporter of the school, and he wanted the institution to prosper. Paschall therefore agreed to Christopher Newport becoming a baccalaureate institution, which took effect in 1971.

In 1970, Dr. James C. Windsor was named Christopher Newport College's second president. A longtime CNC faculty member and administrator, President Windsor was well prepared to oversee the college's growth into its second decade of existence. As course offerings as well as campus clubs and athletic programs continued to expand, Windsor and his colleagues envisioned the next major step in the college's evolution: independence from William and Mary. They believed this step would permit the young college to better manage its affairs and determine its own destiny. President Windsor initiated this process by securing CNC its own advisory board, an important step toward an independent board of visitors.

Although support for independence began to grow in the Newport News community, McMurran adamantly opposed splitting from the "ancient college," as he always called William and Mary. He did not want Christopher Newport to lose this special affiliation with the second-oldest college in the United States. However, after extensive consultation with CNC officials and community leaders, McMurran put his feelings aside to sponsor the necessary legislation in the General Assembly. Boosted by William and Mary's support, the bill passed, and independence was granted, taking effect on July 1, 1977.

As the CNC community rejoiced, however, challenges arose to threaten its continued welfare. State budget shortfalls sometimes left President Windsor with few resources to support the growing campus. Further, he contended with fallout from the 1973 Shaner Report, which resurfaced briefly in 1978. Named after a higher education consultant commissioned by the General Assembly to streamline educational costs, the report recommended closing Christopher Newport and sending its students back to William and Mary. Local state legislators assured President Windsor that such a plan would never take effect, and the idea was never considered seriously. However, the report left residual feelings of fear and insecurity among some CNC faculty and staff that persisted into the early tenure of Windsor's successor, Pres. John E. Anderson Jr. Despite these challenges, President Windsor finished his tenure on a high

note in 1979, managing to secure construction funding for a new administration building and other campus facilities.

Additional budget problems in the early 1980s presented more institutional challenges. A weak economy eliminated potential funding for establishing graduate programs and building a residence hall, among other goals. Despite these setbacks, President Anderson accomplished other important objectives during his tenure, such as modernizing CNC's administrative structure. Student SAT averages increased, and the traditional-aged population grew, offering some balance to adult learners. The student population also grew toward its modern enrollment of nearly 5,000. By working with political and community allies, Anderson successfully secured resources to build a science building. He further strengthened the college's standing by establishing an educational foundation and forging new alliances with community members. During this period, Lewis McMurran was also recognized for his contributions to CNC when Christopher Newport Hall was renamed in his honor.

The college's fourth president, Dr. Anthony R. Santoro, continued CNC's progress by seeking to modernize its image and elevate its standing within the state. Although Christopher Newport had been a fully autonomous baccalaureate institution since the 1970s, some observers still considered it a two-year college or else mistook it for a community college. To correct this inaccurate picture of CNC, President Santoro worked to raise the college to its full potential. In collaboration with political and civic allies, he secured corporate support and was also successful in inaugurating the first graduate programs in 1991. Along with enhancing the quality of students and faculty, he also introduced new academic opportunities, such as study-abroad programs like the President's Summer Seminar in London. Most importantly, President Santoro, Delegate Alan Diamonstein, and Sen. Hunter Andrews led the effort that culminated in Christopher Newport achieving university status in 1992.

CNU continued its physical expansion during the Santoro administration with a large addition to the library and the mid-1990s acquisition of Ferguson High School, which provided additional classroom space for the growing university. The 1994 opening of CNU's first residence hall was another major milestone. The facility was named the Carol K. and Anthony R. Santoro Residence Hall to honor the first president and his wife for their accomplishments. Developing a residential student population later played a key role in the expansion of campus life and encouraged geographical diversity among the student body. Although the university had endured some growing pains, dedicated work by many in the CNU community from the 1970s through the early 1990s seemed to ensure its future prosperity.

By the mid-1990s, Christopher Newport University still faced significant challenges. Increased competition from four-year and community colleges led to flat enrollments. The university was still underfunded with only a small endowment, despite strong political support from area legislators. With the increased institutional competition, CNU also needed to find a new niche in Virginia's higher education system, even as it continued its original mission of serving Peninsula residents. Santoro's successor, former U.S. senator Paul S. Trible Jr., subsequently built upon the foundation laid by all of his predecessors to craft a bold new 21st-century role for Christopher Newport.

Sworn in as CNU's fifth president in January 1996, Trible used the political and leadership skills he had cultivated in the U.S. Congress to build support necessary for transformational growth. To build CNU's distinctive image for potential students across the region, President Trible stressed the university's greatest assets—small class sizes and a dedicated, caring faculty. In turn, he created a vision for Christopher Newport that focused on students obtaining the benefits of a private school liberal arts education for a public school price. By the late 1990s, this message began to resonate among students within Hampton Roads, throughout Virginia, and beyond.

During this period, the university also increased its admission of traditional-aged, residential students to cultivate an on-site learning community. This, in turn, would encourage students to complete their education there and graduate in a timely manner. Therefore, CNU embarked

on a $500 million building campaign that included several new residence halls by the early 2000s, fundamentally reshaping student demographics. Large numbers of students from Northern Virginia and other parts of the state were enrolled, driving the residential student population to nearly 3,000. In time, the out-of-state student population also rose. The presence of brand new, state-of-the-art residence halls gave CNU a key recruiting edge over colleges with older facilities.

The university's building boom continued with the 2000 opening of the Freeman Center, providing a new home for the institution's athletic programs. CNU's 2001 establishment of a NCAA Division III football team was another important milestone in enhancing campus life. However, budget cuts brought on by a sluggish state economy in 2002 slowed CNU's rapid growth for a time. With only limited operational funds, the university was forced to make some painful decisions and eliminate worthy programs, such as nursing, from its curriculum. Despite some controversy over the change to its image, the institution rallied quickly and moved forward.

CNU enriched the cultural life of its campus and region with the construction of the I. M. Pei–designed Ferguson Center for the Arts, which opened in 2004. This facility has since hosted world-class performers such as Tony Bennett and Andrea Bocelli, drawing more than 583,000 guests. As the rapid increase in residential students placed a strain on its aging library and student center, the university focused on building larger replacements. The David Student Union (opened in 2006) and the Paul and Rosemary Trible Library (opened in 2008) provided state-of-the-art facilities for the growing student body. In addition, new academic buildings, such as an integrated science center and a new McMurran Hall, are planned for construction over the next few years.

Beyond enhancing the campus's facilities, President Trible has also focused on expanding academic opportunities and increasing financial support for the university. He has helped to expand foreign travel opportunities for CNU students, allowing them to study all over the world, including at the University of Oxford in the United Kingdom. Working with political and civic leaders, Trible has also secured millions of dollars for scholarships and academic programs from private donors and corporations such as Canon Virginia, Inc., Canon U.S.A., Inc., and Smithfield Foods, Inc. In 2005, Smithfield Foods, Inc., provided CNU with a $5-million gift, used in part to establish the Joseph W. Luter III School of Business, named after Smithfield Foods' former president. Further, in September 2007, an agreement was reached to house the renowned Mariners' Museum library collection at CNU, allowing students and scholars around the world a rare opportunity to access these valuable resources at the Trible Library.

As Christopher Newport has grown, its mission has also evolved. Citing a need for effective national and global leadership, President Trible has encouraged faculty to adapt CNU's curriculum to educate emerging leaders by launching a leadership studies minor as well as the President's Leadership Program. In 2008, the Luter School of Business was also transformed into the Luter College of Business and Leadership to further reinforce the university's commitment to leadership development and civic engagement. While continuing its original charge of educating the region's students, this new leadership focus has given the university a unique identity within the higher education community.

Overall, Christopher Newport's growing combination of first-rate facilities, expanding academic opportunities, and increased public interest has triggered an explosion in applications. From 1996 to 2006, the number of applicants grew by more than 500 percent. Moreover, this infusion of high-ability students prompted grade point averages to rise, along with an average SAT score increase of more than 200 points. The university has attracted national attention for this progress in both media and educational circles. As Christopher Newport University advances its modern mission of educating leaders for the 21st century, its future looks brighter than ever.

One

SCOTTY'S COLLEGE
1960–1969

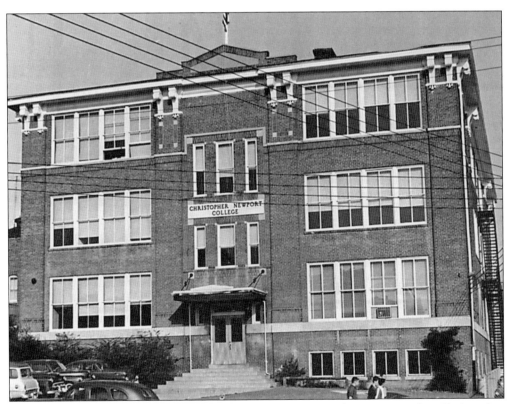

The old John W. Daniel building, located at 222 Thirty-second Street, served as Christopher Newport College's first home. A former high school opened in 1914, the City of Newport News offered the aging facility to CNC for temporary use until a permanent location could be established. With its old, wooden floors reeking of polishing oil, Pres. H. Westcott Cunningham often remarked that he could "smell the new college from a block away."

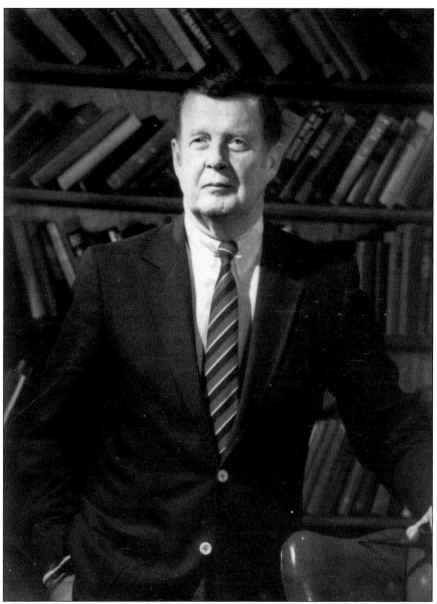

H. Westcott "Scotty" Cunningham was appointed CNC's first director in 1960 and its first president in 1969. A New Jersey native, Cunningham earned his bachelor's degree at the College of William and Mary and pursued graduate studies there and at the University of Michigan. Christopher Newport later awarded him an honorary Doctor of Laws degree in 1982. A decorated U.S. Navy veteran, he commanded a PT boat in the Pacific during World War II and remained in the reserves until concluding his military service as a captain in 1970. Prior to his Christopher Newport tenure, Cunningham taught and was later dean of admissions and student aid at William and Mary. Cunningham left CNC in 1970 to serve as headmaster of the Pingry School in New Jersey. Returning to Virginia in the early 1980s, he served as executive vice president of the William and Mary Society of the Alumni until 1987. Spending his retirement years in his wife's native Gloucester County, Cunningham passed away on July 24, 2007. (Courtesy of the Cunningham family.)

Cecil Cary Cunningham, shown here with her husband, Scotty, was an active campus presence during Christopher Newport's early days. She was a key member on a team that faced the daunting task of creating a college from scratch. Born in Baltimore, Maryland, Cunningham grew up in Gloucester County and graduated from William and Mary. After working for the Civil Aeronautics Board, she served as assistant to the alumni secretary at William and Mary. In later years, she was a special events coordinator for the Colonial Williamsburg Foundation. As Christopher Newport's inaugural first lady, Cunningham involved herself with a variety of causes. She was an early supporter of the Peninsula Fine Arts Center, located initially at Christopher Newport College, and later helped create a campus Panhellenic organization, a key step in the evolution of Greek life at Christopher Newport. After supporting her husband in his administrative duties at both the Pingry School and William and Mary, she joined him in retirement. (Courtesy of the Cunningham family.)

Lewis A. McMurran Jr. is known widely as the "father" of Christopher Newport University. A longtime member of the Virginia House of Delegates, McMurran sponsored the legislation that created the institution and played a key role in choosing its name. A Newport News native, he attended Washington and Lee University and served as a naval officer during World War II. After the war, he was elected to the House of Delegates in 1948, serving there until 1977. McMurran was also active in several civic and business organizations, including the Peninsula Association of Commerce, the Virginia War Memorial Museum, and the Bank of Warwick. In 1957, he chaired Virginia's 350th Anniversary Commission, and he was later chairman of the Jamestown-Yorktown Foundation. An avid historian and a so-called "lover of all things English," CNC officials referred to McMurran affectionately as "Lord Lewis." In 1978, he was the recipient of Christopher Newport's first honorary doctorate. In more recent years, Lewis A. McMurran III has continued his father's tradition of supporting CNU, serving on the board of visitors and funding several scholarships and initiatives.

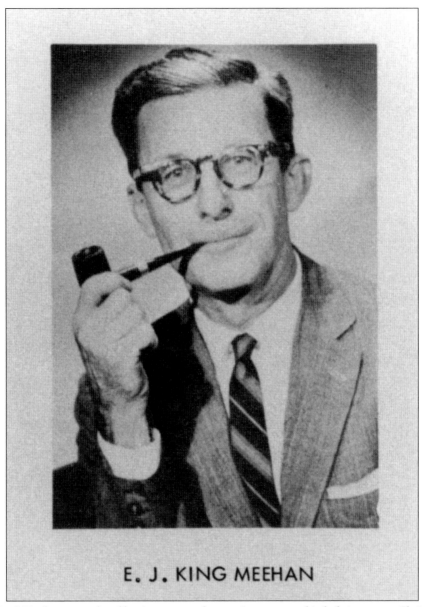

E. J. KING MEEHAN

E. J. "King" Meehan was a local businessman who was instrumental in helping create Christopher Newport College. He also served on the president's advisory council during Pres. James C. Windsor's administration. In the late 1950s, Meehan helped convince government officials that recent population growth warranted a new college on the Peninsula. In the late 1960s, he also lobbied William and Mary officials to grant Christopher Newport four-year baccalaureate status. At the time, William and Mary president Davis Y. Paschall worried that CNC had too few sophomores to yield a viable upperclassmen group. Therefore, there was an inaccurate perception among Newport News residents that he opposed this transition. Comparing this situation to the reluctance to build the James River Bridge some years before, Meehan told Paschall at a 1968 community forum, "If you build it, they will come." Christopher Newport officials considered this speech a defining moment in the young college's history and later dubbed the historic gathering the "Christopher Newport Tea Party."

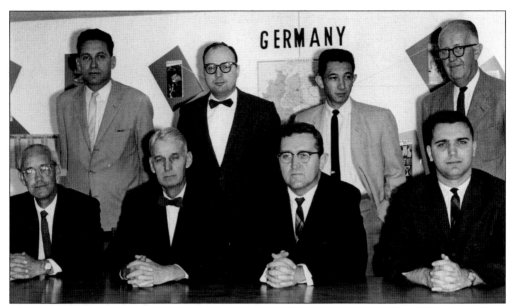

In 1961, President Cunningham hired Christopher Newport's first group of instructional faculty. Williamsburg businessman Robert Usry was the first person appointed, followed by another seven full-time professors and two part-time instructors. From left to right are (first row) Ernest Rudin, Faye Greene, Allen Tanner, and L. Barron Wood Jr.; (second row) Augustin Maissen, James Liston, Robert Vargas, and Usry. Georgia Hunter and Bernard Smith are not pictured.

Although the student body was small in the early 1960s, they did organize a student government association. Pictured here in the Daniel school building is Christopher Newport College's first student government board. From left to right are James Cornette (president), Howard Clark (vice president), Charlotte Anderson (secretary), and Patrick Baldwin (treasurer).

Pictured in this early-1960s photograph are CNC's first staff members. Joining business manager Thomas Dunaway are, from left to right, Arnette Stinson (librarian), Edna Carney (secretary to the president), and Edna Appleton (bookkeeper). Along with a janitor, an admissions director who doubled as the registrar, named Nancy Ramseur, rounded out this small group.

Thomas Dunaway was Christopher Newport's first business manager. A blunt, no-nonsense administrator, Dunaway was notoriously protective of the college's funds, a necessary trait in those first lean years. Faculty members hesitated to even ask him for pens and pencils. Dunaway once assigned a new professor a converted broom closet for an office. Although the accommodations were a bit small, the intimidated instructor gladly accepted them!

Nancy Ramseur joined the Christopher Newport College staff in the early 1960s. She served as the college's first admissions director and registrar, processing student applications and scheduling classes. Tragically, during a trip to England, Ramseur was killed in a car accident. For years thereafter, a Nancy Ramseur Concert Series was held on campus in her honor. (Photograph by the Taylor Publishing Company.)

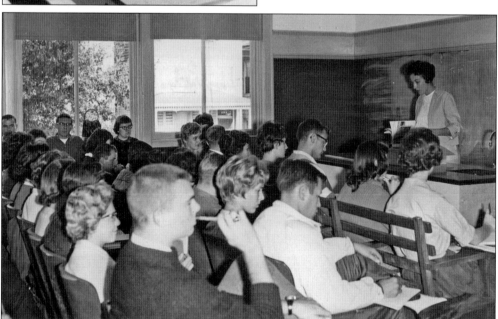

By most accounts, the old Daniel school building was a primitive place to house a college. It had no air-conditioning and a deteriorating infrastructure, and it always reeked of old furniture oil. Prior to Christopher Newport gaining occupancy, someone had written "BURN THIS PLACE" on a wall. Prof. Georgia Hunter is shown in this 1961 photograph teaching a biology class in the Daniel building. (Photograph by Lt. C. L. Tench.)

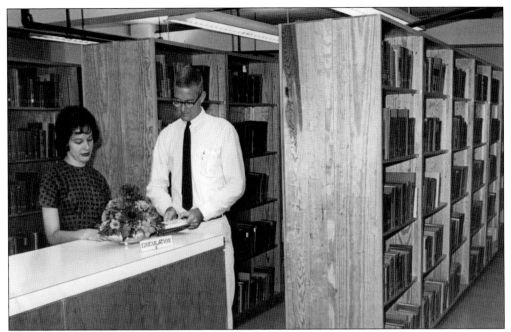

Librarian Bette Mosteller and student Jay Dunn are shown in 1962 at the circulation desk in the college's first library, located in the Daniel school building. In those early years, the library's book collection was limited, prompting Christopher Newport officials to rely heavily on William and Mary's library for support.

James A. Cornette Jr. (left), shown in 1962, was Christopher Newport College's first student body president. After completing his bachelor's degree at William and Mary in 1966, he earned a graduate degree from Duke University. Cornette returned to CNC in 1976, where he has since served as a faculty member in the English department.

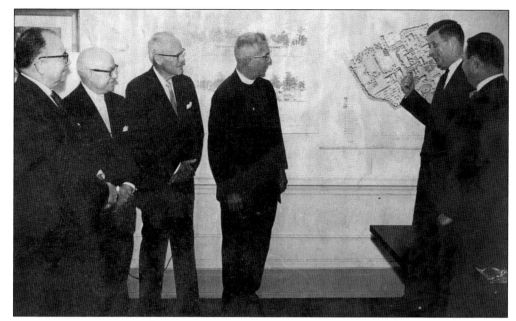

President Cunningham (second from right) is shown in the early 1960s presenting the campus master plan to a group of officials. Cunningham's great strength was his personal charm, which he used frequently to cultivate supporters. He also spoke tirelessly at community events and meetings in order to advance the young college. Such efforts led many to refer to Christopher Newport as "Scotty's College."

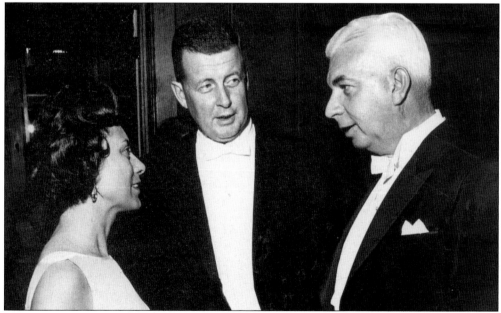

An early initiative at Christopher Newport involved housing the Peninsula Arts Association, which later evolved into the Peninsula Fine Arts Center, on its campus. President Cunningham and his wife, Cecil Cary Cunningham, are shown visiting with Gov. Albertis S. Harrison (right) at a charity ball supporting the new fine arts organization in the early 1960s. (Courtesy of the Cunningham family.)

Dr. James C. Windsor (seated) is shown chatting with a group of students in the early 1960s. Windsor joined the CNC faculty in 1962 and was also named dean of students shortly thereafter. Recalling his first winter in the aging Daniel school building, Windsor once remarked "when the furnace first came on, I could write my name in the coal dust on my desk."

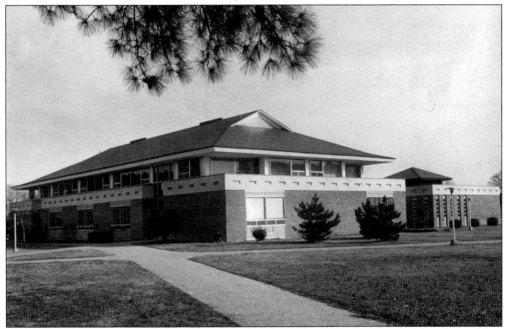

Opened in September 1964, Christopher Newport Hall was the first building to appear on the college's permanent site, a land tract next to Shoe Lane. The building housed all of the college's major components, including nine classrooms, administrative and faculty offices, and a new library. In later years, it would be renamed McMurran Hall to honor Delegate Lewis McMurran's work on behalf of the college.

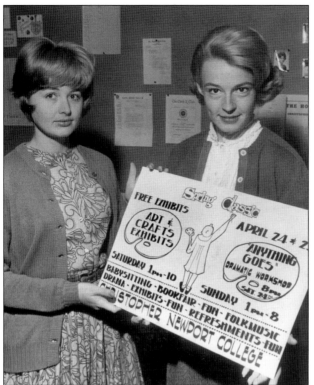

Although Christopher Newport was small in its early years and possessed no residential facilities, a campus life quickly took shape. CNC students, faculty, and staff also sought to raise their institution's profile in the local community. Two students are shown here with an advertisement for a "spring classic," offering such activities as dramatic workshops, book fairs, and music.

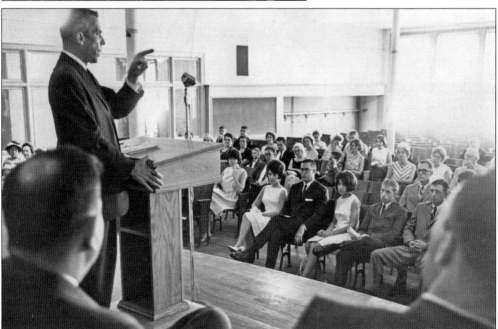

In this 1964 photograph, Judge Forrest B. Wall gives the commencement address to members of the college's second graduating class in the Daniel school auditorium. After completing their junior-college education at Christopher Newport, some of these students would then proceed to William and Mary to earn their baccalaureate degrees.

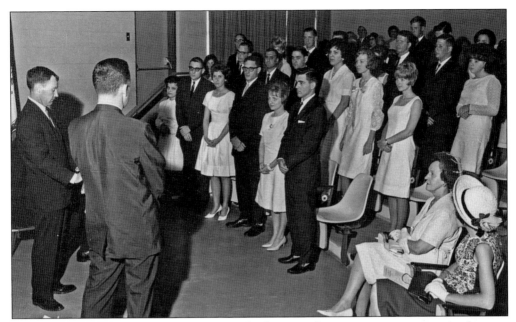

By 1965, commencement ceremonies took place on the permanent campus in the new 200-seat lecture hall (shown here) in Christopher Newport Hall. George Passage, associate editor of the *Daily Press*, was the commencement speaker that year. His wife, Mary, would go on to serve on the CNC Board of Visitors in the late 1970s, followed by service as rector in the early 1980s.

Lt. Gov. Mills E. Godwin Jr. (right) is shown on an official campus tour with President Cunningham in this September 11, 1965, photograph. Godwin was visiting the college to speak at the dedication ceremony for Christopher Newport's new campus, which then consisted of Christopher Newport Hall and the unfinished Gosnold Hall. (Courtesy of the *Daily Press*.)

Gosnold Hall, opened in February 1966, was the second building constructed on the new college campus. It was named after Bartholomew Gosnold, an English explorer and captain of the *Godspeed* during the expedition that founded the Jamestown settlement in May 1607. Over the years, Gosnold Hall housed such departments as biology, chemistry, math, computer science, and physics.

Through the late 1960s, the number of student leaders on campus continued to grow as the college became more established. Christopher Newport's freshman class officers gathered for this 1967 photograph. From left to right are Sandra Reynolds (secretary), Gregory Stevens (president), Walter Rice Jr. (vice president), and Martha Gustin (treasurer).

In May 1967, Christopher Newport's "Lecture Hall Theater" performed one of its earliest productions, a one-act play by Ionesco called *The Leader*. Since there was not yet a campus auditorium, the performers made do with the lecture hall in Christopher Newport Hall as their performance venue. From left to right are Jeanette McDonald, Robert Sauer, James Spielburger, Jay Lewis, and Diane Parrish. (Courtesy of the *Daily Press*.)

Completed in October 1967, Ratcliffe Gymnasium was the third building to appear on the permanent campus site, housing the college's athletic departments. It was named after John Ratcliffe, the second governor of the Jamestown, who was captain of the *Discovery* during the original Jamestown expedition. After the opening of a new athletic center in 2000, Ratcliffe was redeveloped as an academic building. (Photograph by Aycox Photoramic, Inc.)

A group of biology students are photographed preparing for a dissection session in the new Gosnold Hall in December 1967. With this building in operation, students no longer needed to shuttle between Christopher Newport Hall on the new Shoe Lane campus and the old Daniel school building in downtown Newport News to take their classes.

The Captain John Smith Library was completed in June 1968, continuing the extensive 1960s campus-building campaign. Named after the legendary leader of the Jamestown settlement, the library underwent several renovations and expansions during its 40-year existence. The building was later incorporated into the Paul and Rosemary Trible Library, which opened in early 2008. (Photograph by Taylor Lewis and Associates.)

Dr. John H. Willis Jr. served as CNC's 1969 commencement speaker. An assistant vice president at the College of William and Mary, he was the official liaison between the college and Christopher Newport during CNC's transition to a four-year curriculum. Willis went on to teach in William and Mary's English department before retiring in 2002. (Photograph by Thomas L. Williams.)

After President Cunningham announced his departure from Christopher Newport to become headmaster of the Pingry School in New Jersey, faculty and staff honored the Cunninghams with a farewell reception to celebrate their CNC service. Cecil Cary Cunningham is shown receiving a silver platter, intended for entertaining future guests at Pingry. (Courtesy of the Cunningham family.)

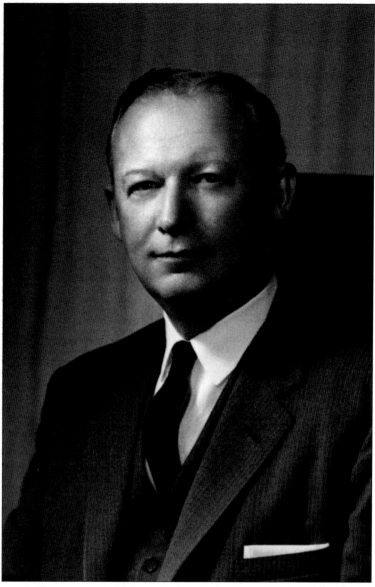

Dr. Davis Y. Paschall was a central figure in Christopher Newport's early history. As president of the College of William and Mary from 1960 to 1971, he oversaw the young institution's creation and evolution. A Lunenburg County native, Paschall earned bachelor's and master's degrees from William and Mary and a doctorate from the University of Virginia. After working as a teacher and principal in the 1930s, he went on to serve as a naval officer during World War II. After the war, Paschall worked for the state education department and eventually became state superintendent of public instruction, guiding Virginia schools through desegregation. As William and Mary's president, some Peninsula civic leaders accused him of opposing CNC's transition to four-year status. However, Paschall asserted that he held no such view. Explaining that Christopher Newport's policies could ultimately impact William and Mary's accreditation, he wanted only to ensure that the institution was ready for such a step, which he later approved. Christopher Newport awarded him an honorary Doctor of Laws degree in 1986. (Photograph by Foster Studio.)

Two

TRANSITION AND INDEPENDENCE 1970–1979

The early 1970s was a time of growth and change at Christopher Newport College. Student enrollment increased steadily, and campus life continued to blossom, outgrowing existing campus facilities. A student is shown here in front of Christopher Newport Hall and a modular trailer (left), which was on site to provide additional classroom and office space. (Photograph by Thomas L. Williams.)

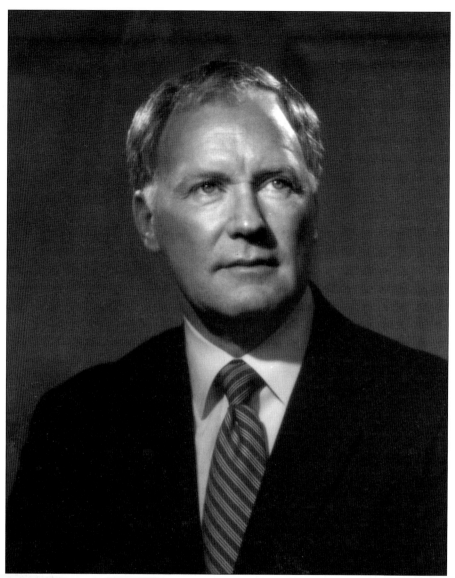

Dr. James C. Windsor became Christopher Newport's second president in July 1970. A West Virginia native, he served in the U.S. Marine Corps during the Korean War and was decorated for valor. He earned his bachelor's degree from William and Mary and his master's degree from Colgate Rochester Divinity School. Windsor later completed another master's degree in psychology from Virginia Commonwealth University and a doctorate from the University of Virginia. CNC awarded him an honorary Doctor of Laws degree in 1986. He joined Christopher Newport as a faculty member in 1962, founding its psychology department. Along with creating the institution's evening college and summer school, Windsor also founded CNC's student counseling center. He later served as dean of students before becoming president. Upon leaving the presidency in 1979, he returned to teaching briefly before founding the Personal Development Institute, a counseling and educational organization in Williamsburg. Active in the mental health movement, Windsor served as chairman of the Virginia Mental Health Board and was also a longtime board member with the Sarah Bonwell Hudgins Foundation. (Courtesy of the Windsor family.)

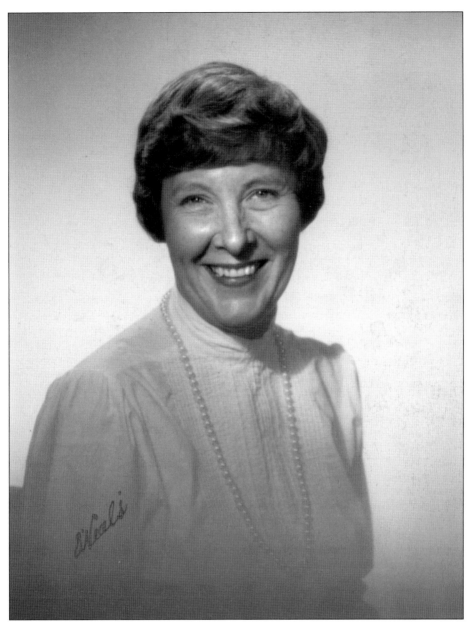

As Christopher Newport College's second first lady, Joan Windsor participated fully in that position's various responsibilities. She received her bachelor's degree from the College of William and Mary in 1956. In 1969, Windsor graduated summa cum laude from William and Mary with a master's degree in guidance and counseling. She later founded Learning Development Services in 1972, a private facility for the evaluation and treatment of exceptional children and adults. An active writer, her articles have appeared in various publications. Windsor is the author of several books, including *The Inner Eye, Dreams and Healing,* and *Passages of Light. The Inner Eye* was also published in German and has been read extensively in Europe. A licensed professional counselor in the Commonwealth of Virginia, she joined her husband at the Personal Development Institute after his departure from CNC. (Courtesy of the Windsor family.)

Opened in 1970, Wingfield Hall was the fourth building constructed on the permanent campus site. It was named after Edward Maria Wingfield, an English soldier and parliament member who helped establish the Virginia Company of London. He was also the first president of the Jamestown settlement. For many years, Wingfield Hall housed Christopher Newport's psychology department. (Photograph by Thomas L. Williams.)

By the late 1960s, the entire college had moved to its permanent location off of Shoe Lane in central Newport News. The busy campus is shown in this early-1970s photograph. Christopher Newport Hall is in the background, and Gosnold Hall is on the left. (Photograph by Taylor Lewis and Associates.)

As President Windsor greeted guests on his October 13, 1971, inauguration, his daughter Robin was unconcerned with the solemnity of the occasion. Instead, she was more focused on finding a place to store her purse. Meanwhile, Joan Windsor (pictured third from left) looked on with a mixture of amusement and disbelief. (Courtesy of the Windsor family.)

Former governor Mills E. Godwin Jr. was Christopher Newport's 1971 commencement speaker. Photographed here are former William and Mary president Davis Y. Paschall (seated on right) and Christopher Newport president Windsor looking on as Godwin speaks. A Suffolk native and William and Mary alumnus, Godwin would go on to serve a second gubernatorial term from 1974 to 1978. (Photograph by Herbert Barnes, courtesy of the *Daily Press*.)

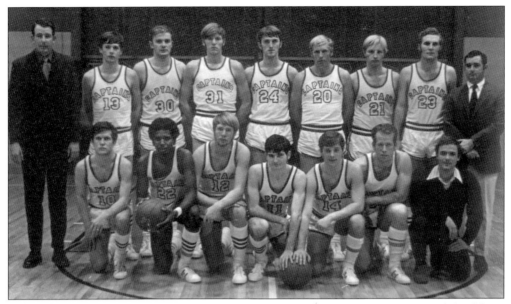

Men's basketball is regarded as one of Christopher Newport's most successful athletic programs. In recent years, the team has appeared in several NCAA tournaments, advancing as far as the Elite Eight. It has also produced many All-Americans and professional players. Shown here is the 1970–1971 team coached by Bev Vaughn, which featured three future CNU Athletic Hall of Fame members (Carl Farris–31, Andrew Waclawski–21, and Robert "Bobby" Arnette–23).

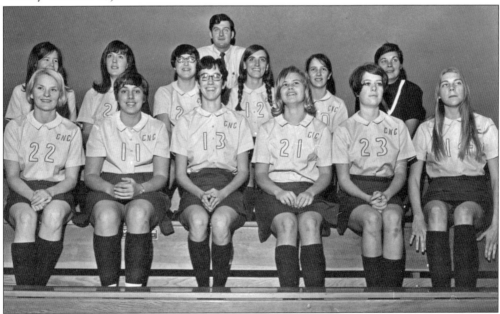

During the 1971–1972 season, Christopher Newport inaugurated its first women's basketball team. Pictured from left to right are (first row) Karen Morgan, Jean Gardner, Alicia Herr, Terry Gooding, Brooke Fancher, and Patsy Phelps; (second row) Brenda Burnett, Carolyn Cox, Beth Brannon, Anda Bossieux, Kathy Digen, and Dr. Jean Pugh; (third row) team manager Steve Franklin. Not pictured is coach Mary Lu Royall.

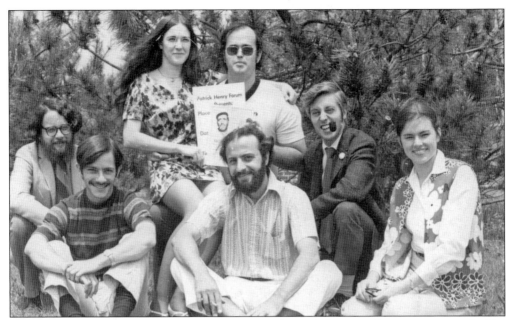

Shown in this early-1970s photograph are members of the Patrick Henry Forum, led by professors Joseph Healey (far left) and Mario Mazzarella (second from right). In an era before professional student-life staff, this group was formed to organize campus activities. With strong student and faculty collaboration, the forum invited speakers to the college and hosted many campus events, including a film series and political debates.

The CNC Sandwich Shop was an early-1970s campus institution owned and operated by T. D. Takis and his wife. Located in Gosnold Hall, the shop served as the principal campus dining location until the student center opened in 1973. In addition to his food service duties, Takis doubled as the campus security guard.

The student center opened in November 1973, providing additional facilities for the growing student body. In its early years, the building contained an information desk, a game room, a cafeteria, a theater, and numerous meeting rooms. It was the vital heart of campus until the David Student Union replaced it in 2006. The student center was torn down in January 2008 to make way for the new McMurran Hall.

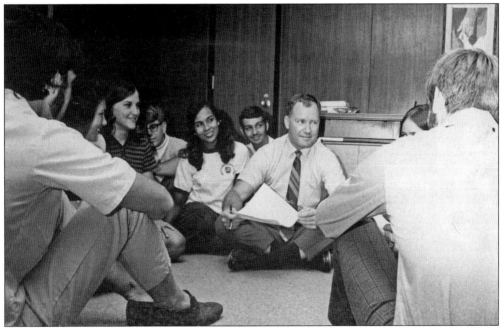

Although President Windsor served in a variety of administrative capacities throughout his career at Christopher Newport, he was a teacher at heart. As a psychology professor by trade, Windsor continued teaching classes during his presidential tenure. He is shown here teaching a course on the psychology of Asian cultures in his office. (Courtesy of the *Daily Press*.)

President Windsor is pictured (first row, third from left) in this early-1970s photograph with William and Mary's board of visitors. He reported to this body until CNC was granted its own board in 1977. Seated next to Windsor is Dr. Thomas A. Graves Jr. (third from right), a strong Christopher Newport supporter who was president of William and Mary from 1971 to 1985. (Photograph by Thomas L. Williams.)

President Windsor is shown with his secretary, Edna Carney. One of his objectives as president was to improve CNC's relationship with the City of Hampton, which was still bitter about the college's placement in Newport News. Through the 1970s, Windsor hosted CNC commencement ceremonies at the Hampton Coliseum, inviting community members to hear prominent national speakers. Hampton residents appreciated this effort, and the ceremonies were well attended.

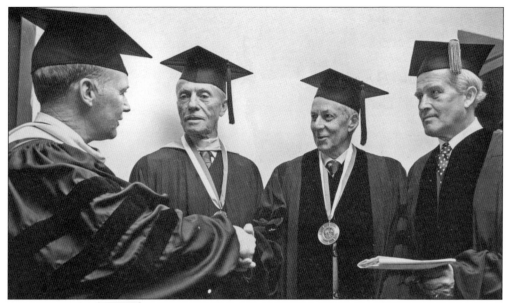

Dr. Wernher von Braun (far right), a German rocket technology pioneer and National Aeronautics and Space Administration (NASA) official, was Christopher Newport's 1974 commencement speaker. He developed the German V-2 rocket during World War II and was later regarded as the father of the U.S. space program. Because of von Braun's wartime Nazi Party affiliations, his Hampton Roads appearance troubled some within the local Jewish community. (Courtesy of the *Daily Press*.)

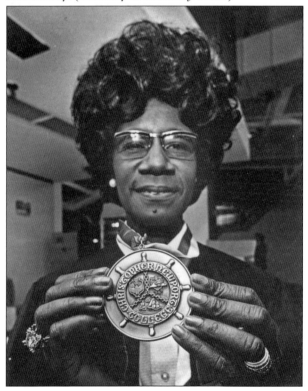

Congresswoman Shirley Chisholm was CNC's 1975 commencement speaker. This New York Democrat was the first African American woman elected to Congress (in 1968) and the country's first major party African American presidential candidate (in 1972). Her controversial pro-abortion stance prompted college officials to arrange for extensive security during the graduation ceremony. Chisholm is shown with her new Christopher Newport College medallion. (Photograph by Kenneth R. Silver, courtesy of the *Daily Press*.)

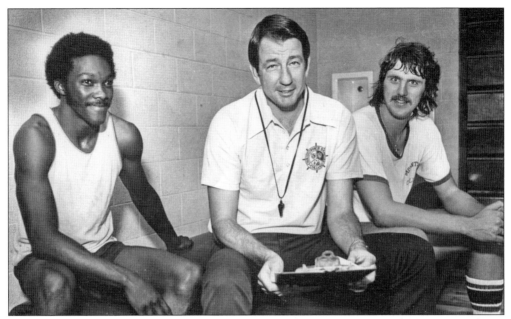

Portsmouth, Virginia, native Bev Vaughan (center) is often referred to as the "father" of CNU athletics. A William and Mary alumnus and U.S. Army veteran, he was Christopher Newport's first athletics director, serving from 1967 to 1987. Along with leading other teams, Vaughn coached the men's basketball program for 14 seasons, compiling a record of 204 wins to 128 losses. He is shown in 1975 with two of his students.

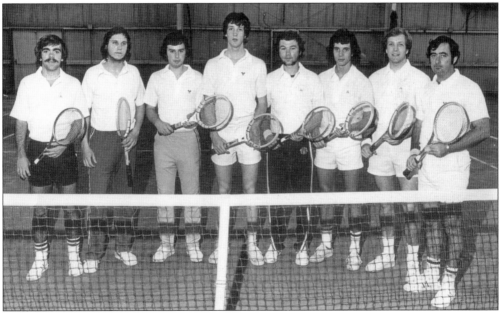

Men's tennis is another one of Christopher Newport's highly successful programs. Over the years, the team has been Dixie Conference Champion several times and was most recently USA South Conference Champion in 2008 under coach Rush Cole. Shown here is the 1976 team, which earned a 9 and 3 season record. The team went on to become Dixie Conference cochampions, the first of five consecutive conference titles.

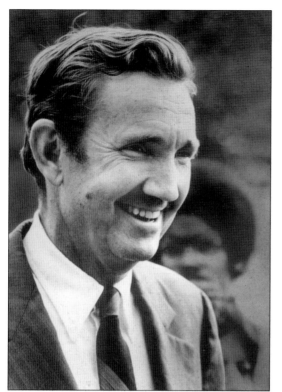

William Ramsey Clark was Christopher Newport's 1976 commencement speaker. His father, Thomas C. Clark, was the U.S. attorney general in the Truman administration and later served on the U.S. Supreme Court from 1949 to 1967. A Texas native and U.S. Marine Corps veteran, Ramsey Clark served as U.S. attorney general in the Johnson administration from 1967 to 1969.

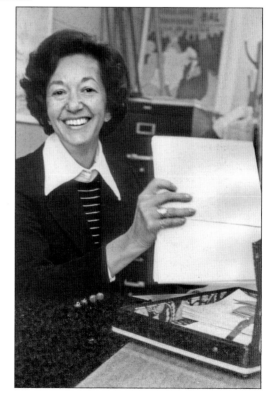

Dr. Rita C. Hubbard was a longtime Christopher Newport faculty member, serving from 1969 to 2001. A specialist in communication studies, she was the founding chairperson of the department of fine and performing arts, the department of arts and communication, and the department of communication studies. Granted emerita status upon her 2001 retirement, Dr. Hubbard has since been active in researching CNU's history.

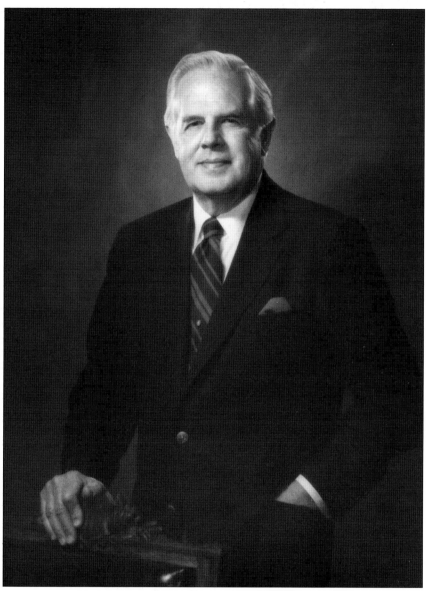

Few have forged a stronger bond with CNU than Harrol A. Brauer Jr., who was the first rector of its board of visitors from 1976 to 1982. A Richmond native, Brauer earned a bachelor's degree from the University of Richmond before serving as a naval officer in the Pacific during World War II. After marrying Elizabeth "Skeeter" Hill and settling in Hampton, he pursued a broadcasting career and became vice president of sales for WVEC TV. A founder of WHRO Public Television and chairman of the Virginia Telecommunications Board, Brauer served as chairman of the Hampton School Board and lieutenant governor of Kiwanis. He was vestry junior warden, lay reader, and Eucharistic minister at the historic St. John's Church. At Christopher Newport, Brauer chaired the advisory council prior to its separation from William and Mary. He was bestowed with an honorary Doctor of Laws degree in 1984, the Distinguished Service Medallion in 1985, and the Founders' Circle Medal in 2000. The Brauers also established professorships and scholarships in the school of business, from which their sons Harrol, William, and Greg graduated.

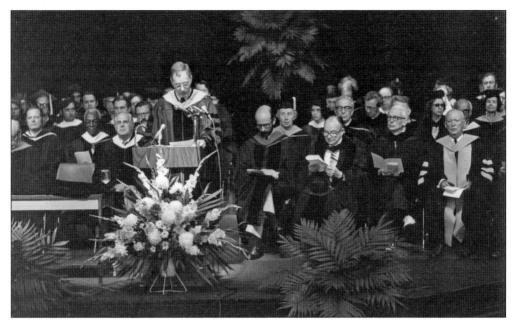

On July 1, 1977, officials from CNC and William and Mary gathered in the campus theater to officially acknowledge Christopher Newport's new status as an independent, public college. Speakers commented on the institution's development before CNC rector Harrol A. Brauer Jr. gave the official address. President Windsor is shown introducing special guests. (Photograph by James Livengood, courtesy of the *Daily Press*.)

Four individuals instrumental in Christopher Newport's founding and development are pictured right before CNC's independence ceremony. From left to right are former CNC president H. Westcott Cunningham, former William and Mary president and chancellor Alvin Duke Chandler, former William and Mary president Davis Y. Paschall, and CNC president Windsor. A framed drawing of the Daniel school building is in the background. (Courtesy of the *Daily Press*.)

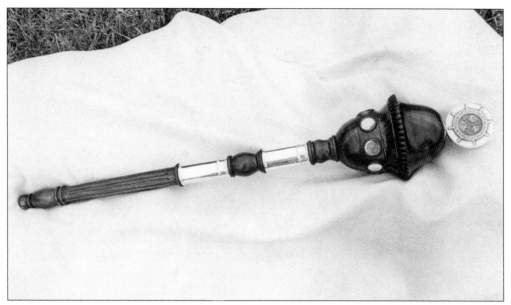

To acknowledge Christopher Newport's independence from William and Mary, President Windsor and other CNC officials thought it was important to provide the college with an official mace. Utilized for military purposes in medieval times, maces are now considered symbols of authority and are used in ceremonial occasions. Dr. Nancy Melton, an assistant to the president with training in commercial art, designed CNC's mace. (Courtesy of the *Daily Press*.)

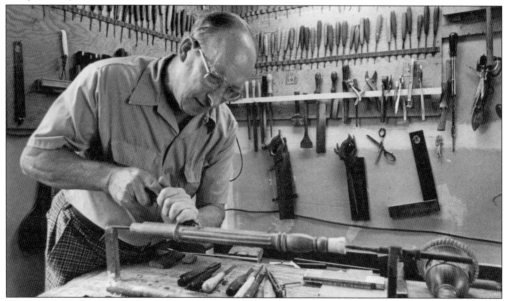

Johannes J. Heuvel Sr., master cabinetmaker with the Colonial Williamsburg Foundation, was commissioned in 1977 by CNC officials to construct the college's mace. A Dutch native who survived the Nazi occupation during World War II, Heuvel and his family immigrated to America in 1955. He also created official gifts for notable Colonial Williamsburg visitors, including Walter Cronkite and Queen Elizabeth II. (Photograph by Joseph Fudge, courtesy of the *Daily Press*.)

This 1977 photograph shows CNC's first independent board of visitors. From left to right are (first row) Billie Pile, Harry H. Wason, President Windsor, rector Harrol A. Brauer Jr., Mary Passage, and Stephen J. Wright; (second row) W. R. Walker, F. Hunter Creech, Dr. David G. Fluharty, William E. Allaun Jr., B. M. Millner, and William Savage. Stephen D. Halliday is not shown. (Photograph by James Livengood, courtesy of the *Daily Press*.)

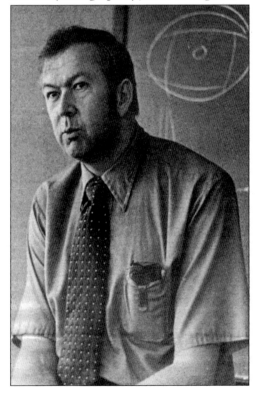

Known as a kind and decent man among students and faculty alike, dean of students William H. Polis was a highly respected campus leader. A Rhode Island native, Polis joined Christopher Newport in 1969 after serving as director of public relations at Keuka College in New York. His unexpected death from a heart ailment in April 1978 was a tragic blow to the CNC community.

Mary Passage was a central figure in Christopher Newport's early history. A career educator, she served as vice rector and rector of the board of visitors. Mary Passage Middle School in Newport News, Virginia, is named in her honor. Passage is shown in this 1977 photograph speaking with fellow board members Dr. David G. Fluharty (center) and William E. Allaun Jr. (Photograph by James Livengood, courtesy of the *Daily Press*.)

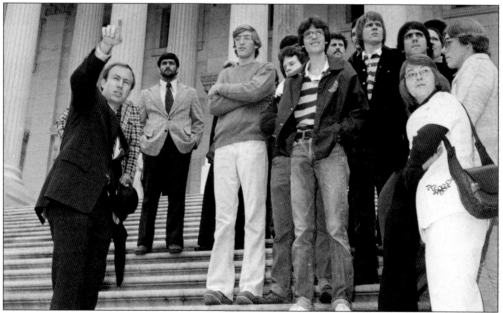

Paul S. Trible Jr., a young Virginia congressman in this late-1970s photograph, is pictured showing Christopher Newport students around Washington, D.C. At the time, House Speaker Thomas "Tip" O'Neill predicted that one among a trio of new congressmen, including Trible, Albert "Al" Gore Jr., and J. Danforth "Dan" Quayle would ultimately become president. Trible likes to say that he alone accomplished that goal—by becoming president of CNU!

Appearing with Harrol A. Brauer Jr. (right) in this photograph is Christopher Newport's 1978 commencement speaker, U.S. senator George S. McGovern. This South Dakota native and World War II combat veteran was well known for his opposition to the Vietnam War. A former congressman, McGovern served in the Senate from 1963 to 1981 and was the 1972 Democratic Party presidential nominee. (Courtesy of the Brauer family.)

One of CNU's longest serving professors is Dr. Mario D. Mazzarella, a historian first appointed to the faculty in 1969. Pictured in 1978, he chaired the history department in the late 1980s and later served as President Santoro's executive assistant. Throughout his teaching career, he has brought countless speakers to campus and coordinated several academic events. Students have selected him three times as professor of the year.

Three

ADVERSITY AND PERSEVERANCE 1980–1986

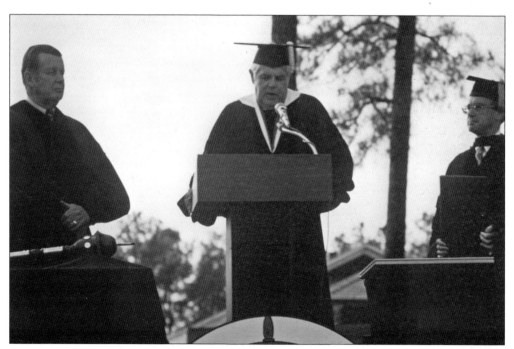

The early 1980s represented an important transition in Christopher Newport's history. While the institution's first two presidents were closely affiliated with William and Mary, CNC's 1980 appointment of an outsider, Dr. John E. Anderson Jr., as its third president represented continued movement toward forging its own independent identity. From left to right are former president H. Westcott Cunningham, rector Harrol A. Brauer Jr., and President Anderson.

Ohio native Dr. John E. Anderson Jr. was inaugurated Christopher Newport College's third president in November 1980. He earned his bachelor's degree in philosophy from the University of Akron, followed by his Ph.D. in psychology from Ohio State University. Anderson taught at Florida State University and later joined Georgia's Columbus State University, serving for 17 years as dean, vice president, and finally, as acting president. Anderson was also chairman of visitation committees for the Southern Association of Colleges and Schools, as well as a lecturer and seminar leader for the Federal Judicial Center in Washington, D.C. At Columbus State, Anderson served on the committee that authored the original guidelines for the University System of Georgia's core curriculum. Attracted by the possibilities of an autonomous urban school that could engage with its outside community, he found a home at Christopher Newport. After leaving the presidency in 1986, Anderson returned to full-time teaching, serving for several years as a department chair in CNU's school of business. He concluded his teaching career as a distinguished professor of psychology, retiring in 2003.

Joyce Querry Anderson pursued a career in education before assuming her duties as Christopher Newport College's third first lady. An Akron, Ohio, native, Anderson attended the University of Akron and later earned a bachelor's degree in elementary education from Columbus State University in Georgia. She also completed some graduate coursework and taught in the City of Columbus public school system for several years. In 1976, Anderson was named Muscogee County, Georgia, Teacher of the Year. At Christopher Newport, she joined her husband in building strong partnerships between the college and local community leaders. Anderson hosted parties regularly and reached out in particular to the local military community. After her husband left the presidency, she returned to teaching and served for several years in the Newport News Public School System before retiring in 1998. (Photograph by Stuart Gilman, courtesy of the Anderson family.)

U.S. senator John W. Warner Jr. (first row, second from left) was Christopher Newport's 1980 commencement speaker. A World War II and Korean War veteran, Warner served as navy secretary and 1976 American Bicentennial Commission director before his election to the Senate in 1978. Senator Warner visited campus frequently, even serving again as commencement speaker in 1996, before his retirement from the Senate in 2009.

Shown here around 1980 is Gosnold Hall. At the time, CNC consisted of only Christopher Newport Hall, Gosnold Hall, Wingfield Hall, Ratcliffe Gymnasium, Smith Library, and the Student Center. While growth in student, faculty, and staff numbers prompted a need for additional facilities, challenging economic conditions in the early 1980s made it difficult to secure funding for construction.

The administration building opened in the fall of 1980, helping to ease the shortage of office space on the growing campus. President Windsor began planning for this facility during his tenure and also secured state appropriations for its construction. In a 1979 campus visit, Gov. John Dalton helped break ground on the new building. It has since been used to house such offices as admissions and financial aid.

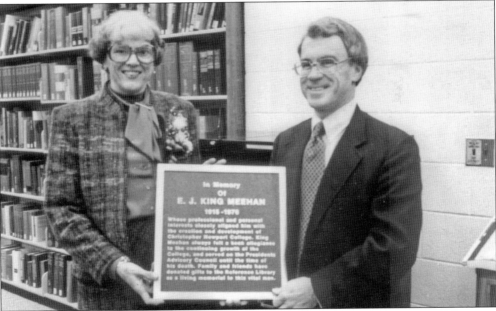

President Anderson is shown in this 1981 photograph presenting a commemorative plaque honoring E. J. "King" Meehan to his widow, Elsie Meehan. King Meehan had passed away in 1976 after a long battle with cancer. Along with his staunch support in helping establish the college, Meehan made generous donations to the Captain John Smith Library that were long remembered by the CNC community.

In the early 1980s, the Captain John Smith Library was adjusting to the needs of its growing campus. In 1978, the library broke ground on a $1-million addition that was completed in late 1979, nearly doubling the building's size. This allowed for an expansion in library materials, including books, periodicals, and technical equipment.

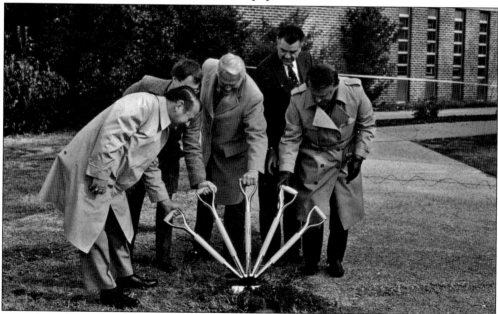

In December 1982, President Anderson (second from left) and other dignitaries broke ground on a new campus science building. To better accommodate the visiting officials during the ceremony, Anderson had a special five-handled shovel constructed for the event. For years thereafter, this unique shovel was requested frequently for ground-breaking ceremonies throughout Hampton Roads.

The *Captain's Log* has served as Christopher Newport's student newspaper for several years. Replacing a small pamphlet known as *Chris' Crier*, the first *Captain's Log* was published in November 1963. In recent years, it has also been available online. A group of students are shown here reading the latest issue in this early-1980s photograph.

The 1983 homecoming court is shown standing in the basketball arena in Ratcliffe Gymnasium. For several years, homecoming was held each February to coincide with basketball season. However, with the addition of a football team in 2001, homecoming events were moved to the fall. Homecoming is now held each October during a special home football game.

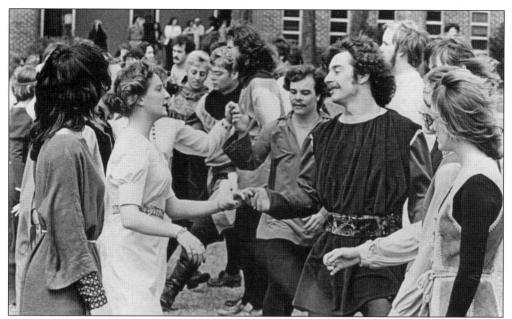

The renaissance fair was an annual Christopher Newport tradition for several years. First held in 1976, the fair consisted of costumed experts, speakers, and panels who discussed the medieval and Renaissance eras. Held regularly through the 1990s, the fair was designed to allow students and community members to experience "living history" by participating in demonstrations and other events.

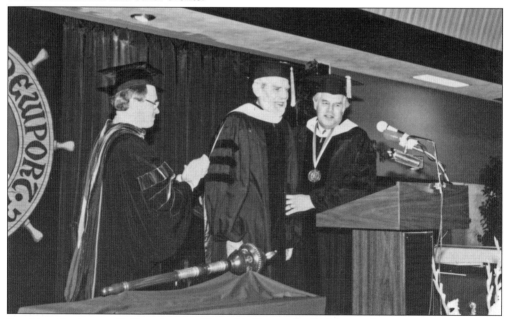

President Anderson (left) and rector Harrol A. Brauer Jr. (right) are shown presenting August F. Crabtree with an honorary doctorate at CNC's 1984 commencement ceremony. Crabtree was an artist and master wood carver who specialized in building model ships. The Mariners' Museum in Newport News houses a gallery of his work, which has long been one of its most popular exhibits. (Courtesy of the Brauer family.)

Dr. James M. Morris is shown in the mid-1980s teaching an American history class. A Christopher Newport faculty member from 1971 to 2002, Morris specialized in American maritime and naval history, as well as military history. He received his Ph.D. in 1969 from the University of Cincinnati and published his first book, *Our Maritime Heritage*, in 1979.

As state employees, Christopher Newport faculty and staff are frequently given service awards to acknowledge their work on behalf of the institution and the commonwealth. President Anderson (left) and rector Mary Passage are shown in the mid-1980s presenting such an award to former president James Windsor, who was then serving as a CNC psychology professor.

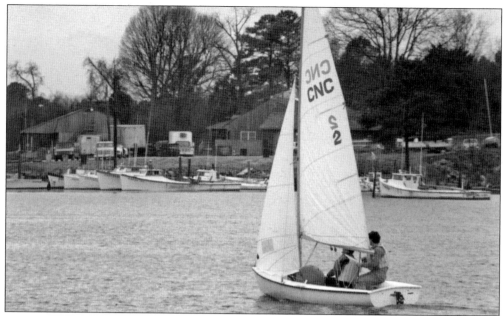

The sailing team has enjoyed a long and distinguished history at Christopher Newport. Established by faculty members Jane and George Webb, its sailing waters include both Deep Creek and the open James River. Led by coach Daniel "Dan" Winters since 1991, the team competes regularly with other colleges through the Middle Atlantic Intercollegiate Sailing Association.

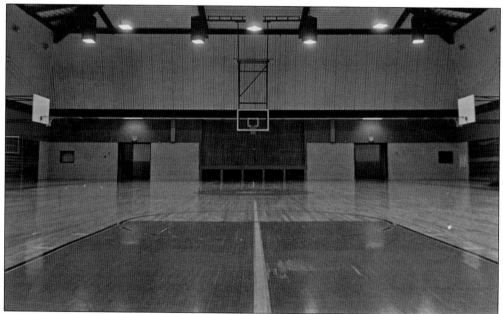

The basketball court in Ratcliffe Gymnasium was a longtime focal point for Christopher Newport athletics. For years, students, faculty, and staff packed into the bleachers to watch basketball games or to participate in other campus events. Although this facility was renovated and redeveloped for academic use, its legacy carries on in the Freeman Center's basketball arena, which opened in 2000.

Throughout the 1980s, the student center was a central gathering area for CNC students, containing such amenities as a dining facility, a bookstore, and a game room. In the absence of residence halls, this facility gave students a place to meet or spend time between classes. Students are shown in this photograph studying, listening to music, and reading newspapers.

Prof. Ruth Ownby Simmons is shown in the mid-1980s working with a couple of biology students. Simmons served on the Christopher Newport biology faculty from 1967 to 1992, teaching courses in microbiology, anatomy, and physiology. Before joining CNC, she earned her bachelor's degree from Carson Newman College and also completed a master's degree in education from the University of Virginia.

57

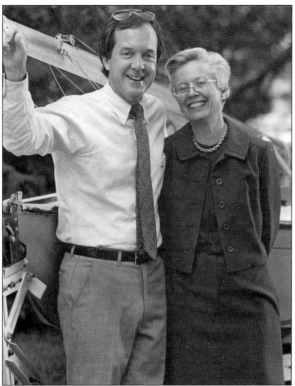

Faculty members Drs. Jane and George Webb came to CNC in 1973 from Tulane University. Along with establishing the varsity sailing team, they helped build a nested set of courses within physics and the computing sciences, developing major fields in four areas. By 2000, the master's degree program in applied physics was one of the top 10 applied physics master's programs in the country, according to a Sloan Foundation study.

A major achievement during the Anderson administration was the construction of the new science building, which opened in the spring of 1985. The facility provided much-needed laboratory and classroom space for the growing campus and has since housed the department of biology, chemistry, and environmental science. The outer facade was later enclosed to make room for additional office space.

Gov. Charles S. Robb (center) visited Christopher Newport to tour the new science building on its grand-opening day. He had visited campus before, serving as keynote speaker for the January 1978 commencement ceremony. Governor Robb, a son-in-law of U.S. president Lyndon B. Johnson, is shown speaking with CNC board of visitors member Martha Ailor. (Courtesy of the *Daily Press*.)

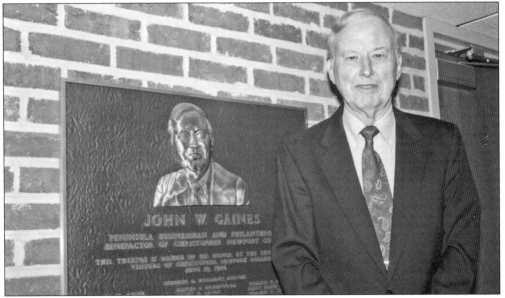

Peninsula businessman John W. Gaines developed close ties to Christopher Newport during his retirement years. President Anderson first met him in the Smith Library, where Gaines liked to read newspapers and business periodicals. Over the years, Gaines became a key institutional benefactor, donating funds for scholarships and other campus needs. To acknowledge his generosity, the board of visitors renamed the student center auditorium Gaines Theater in his honor.

Christopher Newport alumnus and former rector Alan S. Witt is a prominent Peninsula businessman and public servant. A former Newport News City Council member, he was appointed to the board of visitors during the Anderson administration and was also active in the alumni association. Witt is currently chief executive officer of Witt Mares, a regional accounting and business-consulting firm. (Courtesy of Alan S. Witt.)

Bank executive Gordon L. Gentry Jr. enjoys a reputation as one of Christopher Newport's most active supporters. He spearheaded fund-raising efforts for CNC through the 1970s and was vice rector on the board of visitors in the 1980s. More recently, Gentry has been a board member with the Joseph W. Luter III College of Business and Leadership. (Photograph by Olan Mills Studios, courtesy of Gordon L. Gentry Jr.)

Gerard Mosley is the top men's soccer player in CNU history. He was named a two-time All-American in 1985 and 1986. He also helped lead the Captains to an 18 and 5 record in 1986 and their first-ever berth in the NCAA Division III Tournament. Mosley is the only Christopher Newport soccer player to ever have his number retired.

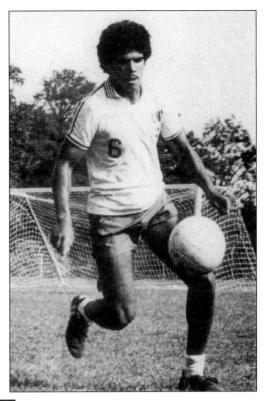

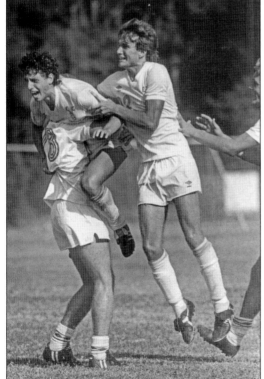

Christopher Newport's Steven Cook (left) and Luigi Fiscella (second from left) celebrate a goal during the Captains' 2-1 victory over No. 1 ranked University of North Carolina–Greensboro in 1986. Joining them is fellow teammate Cary Smith (third from left). The Captains finished the season with 18 wins and 5 losses and earned the school's first NCAA bid in men's soccer.

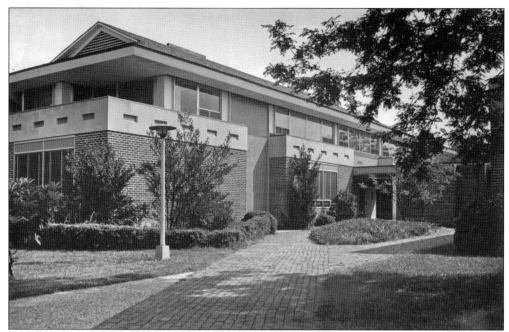

Christopher Newport Hall was renamed McMurran Hall in 1986 to honor Lewis A. McMurran Jr. for his role in helping create CNC. Although it housed nearly the entire institution in the mid-1960s, McMurran Hall was occupied solely by the history department and some administrative offices by the early 2000s, a reflection of the college's rapid physical growth.

The Honorable Lewis A. McMurran Jr. and his wife, Edie, are shown inspecting the official plaque commemorating the renaming of Christopher Newport Hall in his honor. The college also honored him by commissioning his portrait. Painted by his sister, Agnes McMurran Johnson, the portrait shows McMurran in his academic regalia and is now located in McMurran Hall.

Four

INTO A UNIVERSITY
1987–1995

The late 1980s ushered in a new era at CNC as a new president was sworn into office. Pres. Anthony R. Santoro's (second from right) 1987 inauguration ceremony is photographed here. Former presidents Cunningham (far left) and Windsor (second from left) look on as rector Erwin B. Drucker addresses the crowd. (Courtesy of the Santoro family.)

Dr. Anthony R. Santoro was inaugurated as Christopher Newport's fourth president in 1987. Born in Chicago, he earned his bachelor's degree from the College of the Holy Cross, followed by a master's degree from the University of California and a Ph.D. from Rutgers University. After serving as a faculty member and department chair, Santoro was vice president of Briarcliffe College and Ladycliff College in New York state and later president of St. Joseph's College in Maine from 1979 to 1987. Upon concluding his tenure as Christopher Newport's president in 1996, he resumed his teaching career as a distinguished professor of history at CNU. Santoro is an honorary professor at Foshan University in China and has lectured in several countries. A specialist on the Byzantine Empire, he is also highly regarded for his work in the field of National Socialist German history. Santoro is president of the National Genocide Education Project and active in the World Affairs Council of Greater Hampton Roads. (Photograph by Bachrach, courtesy of the Santoro family.)

First Lady Carol K. Santoro was an active presence on the CNU campus during her husband's nearly nine-year tenure as president. Born in Westchester County, New York, Santoro attended Mount Holyoke College, where she was awarded the Merrill Prize and was named a Sarah Williston Scholar. She later worked in advertising in New York City before completing her bachelor's degree with honors from Briarcliff College. She has been active in community and cultural affairs throughout her adult life. Within the Hampton Roads region, Santoro served on several boards, including the National Council of Christians and Jews, the Newport News Public Library, the Peninsula Fine Arts Center, and the Peninsula Camp Fund. A strong advocate against domestic violence, she has served as a hotline volunteer and spokesperson with the Virginia Peninsula Council on Domestic Violence. (Photograph by Bachrach, courtesy of the Santoro family.)

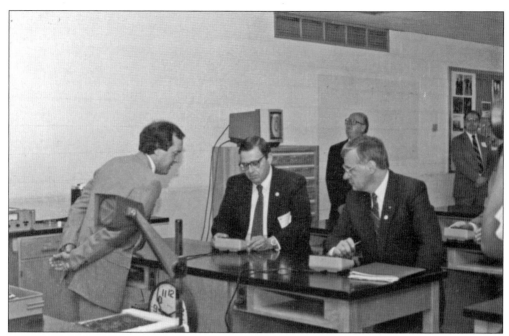

In 1987, Gov. Gerald L. Baliles (seated on right) visited campus to inspect a new classroom communication system known as Classtalk. Dr. George Webb (left) is shown demonstrating it to President Santoro (center) and Governor Baliles. Spearheaded by the physics department, CNC served as the first alpha test site for this new technology.

Inspired by the 1986 film *Platoon*, Dr. Mario Mazzarella and other faculty members sought to explore the issues involved in the Vietnam War on the Christopher Newport campus. This culminated in the well-attended April 1987 *Platoon* Symposium, a three-day conference headlined by U.S. Navy veteran and Medal of Honor winner Robert "Bob" Kerrey (left), a former Nebraska governor who would go on to serve in the U.S. Senate.

CNU has long enjoyed an outstanding track and field team, which has won numerous championships and generated many All-Americans. Shown here is its first national championship track and field team, the 1987 outdoor squad. Pictured from left to right are Karen Humphrey, Sheila Trice, Michelle Dickens, Claudia Stanley, unidentified, head coach Vince Brown, Sandy Shelton, Lisa Dillard, and assistant coach Chris Davidson.

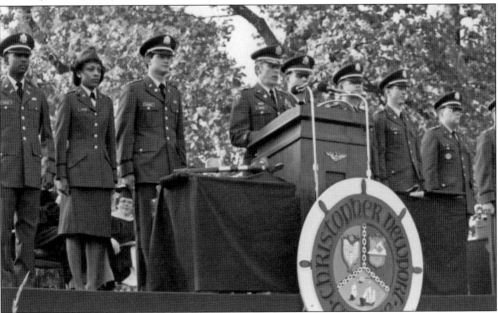

The Army Reserve Officers Training Corps (ROTC) has maintained a strong presence at Christopher Newport for several years, offering classroom and field-based training. The program is a component of the College of William and Mary's ROTC program, known as the Revolutionary Guard Battalion. It commissions several new U.S. Army second lieutenants each year.

President Santoro is shown in this 1988 promotional photograph with a group of CNC students. In an effort to enhance Christopher Newport's public profile, Santoro planned to achieve several goals during his tenure. These included increasing the number and quality of faculty, implementing graduate programs, and elevating the institution to university status.

Real estate executive Erwin B. Drucker was a longtime Christopher Newport supporter. A former board of visitors member, he served as rector in the late 1980s. Drucker is shown with his wife, Rona, displaying a rare set of books about the post–World War II Nuremberg Trials they had donated to the Smith Library. (Courtesy of the Santoro family.)

Lt. Gov. L. Douglas Wilder was Christopher Newport's 1988 commencement speaker. A Korean War veteran and former state senator, he would later become the nation's first African American governor before concluding his political career as the mayor of Richmond, Virginia. From left to right are Wilder, President Santoro, and Lloyd U. Noland Jr., former chairman and chief executive officer of the Noland Company.

Mary V. Bicouvaris (center) was a prominent Peninsula educator with close ties to CNU. A native of Greece, she taught in Hampton, Virginia, public schools for 27 years and was named the 1989 National Teacher of the Year. Bicouvaris served on the board of visitors from 1989 to 1995 and later joined the education department, teaching there until her passing in 2001. (Courtesy of the Santoro family.)

Karen Barefoot was one of the top Division III women's basketball players of all time. At the close of her career in 1994, she was a three-time All-American and the only player in NCAA history (male or female) at any level to score at least 2,000 points (2,073) and have at least 1,000 assists (1,002). She later went on to a distinguished coaching career.

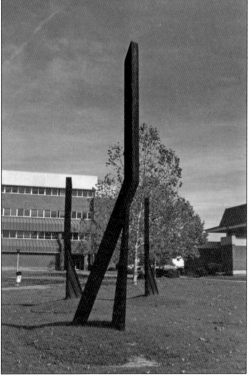

Shown in the fall of 1989, three sculptures known as *The Ships* were longtime campus fixtures. They represented the three ships under Capt. Christopher Newport's command on the expedition that founded Jamestown in May 1607. The sculptures were a gift to the university in memory of Forrest W. Colie Jr., the architect who drafted the original campus master plan and designed its first buildings.

70

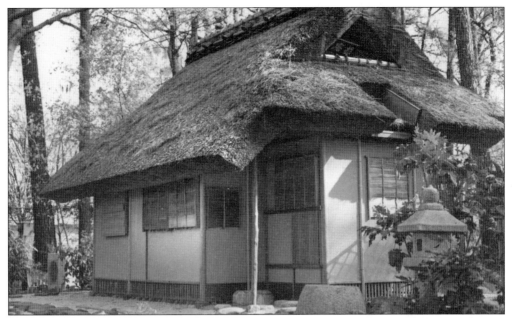

On September 20, 1989, the Japanese Tea House in Virginia was dedicated on the Christopher Newport campus. A reproduction of the Ennan Tea House in Kyoto, Japan, it was constructed originally for an exhibit in the National Gallery of Art and was later given to the Commonwealth of Virginia. The teahouse resided on campus until the fall of 2005, when it was moved to the Peace Garden in Newport News Park.

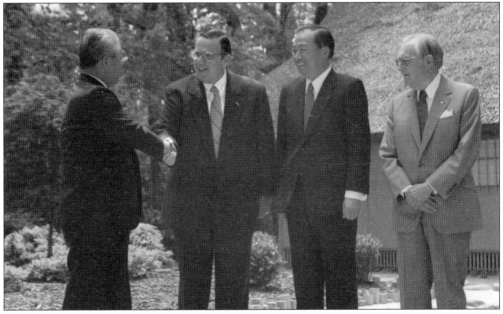

Executives from Canon and the Noland Company graciously raised the funds needed to move the teahouse and have it rebuilt on campus by expert Japanese craftsmen. President Santoro is shown here thanking them for their generosity. From left to right is Shin-ichiro Nagashima from Canon, Santoro, Dr. Keizo Yamaji from Canon, and Lloyd U. Noland Jr. from the Noland Company.

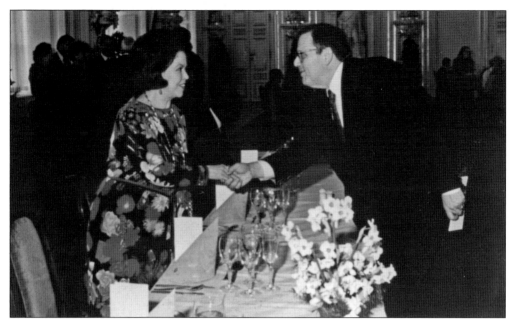

A key priority for President Santoro during his administration was to create international study opportunities for Christopher Newport students. He therefore traveled widely to arrange partnerships with foreign institutions. Santoro is shown at an international conference in Prague, meeting Academy Award–winning actress Shirley Temple, who was the then–U.S. ambassador to Czechoslovakia. (Courtesy of the Santoro family.)

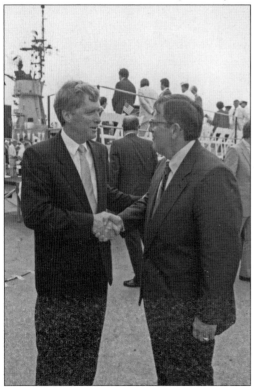

President Santoro is shown visiting with U.S. vice president J. Danforth "Dan" Quayle at the June 3, 1989, commissioning of the U.S. Navy submarine USS *Newport News*. Santoro chaired the celebration committee that helped organize the event. Built and launched by Newport News Shipbuilding, the vessel was sponsored by Rosemary Trible in 1986. (Courtesy of the Santoro family.)

Hunter Andrews was a longtime state legislator who assisted CNU on numerous occasions. A Hampton native and William and Mary alumnus, Andrews served in the state senate from 1964 to 1996, spending the last 16 years of his tenure as majority leader. Among his many contributions to the university were securing funds for library expansions and for construction of the first residence hall.

One of CNU's most valued supporters is Newport News attorney Alan A. Diamonstein. A University of Virginia alumnus and U.S. Air Force veteran, Diamonstein served in the Virginia House of Delegates from 1968 to 2001. In that capacity, he was instrumental in assisting Christopher Newport in nearly every stage of its development, securing crucial financial and political support for the young institution. (Courtesy of the Honorable Alan A. Diamonstein.)

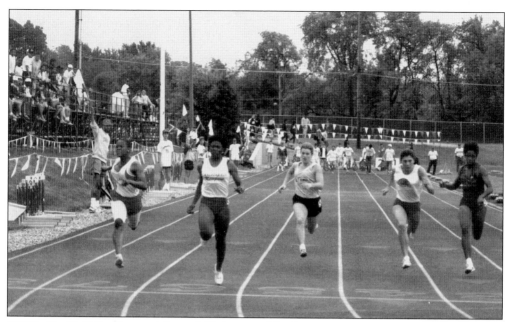

CNU's Sheila Trice (second from left) is arguably the greatest track and field athlete in Division III history. She won 12 individual national championships and added three more with relay teams in her career from 1986 to 1990. She earned All-America recognition 31 times. At the 1989 NCAA indoor championships, Trice won four events, a feat matched only by famed athlete Jesse Owens.

Lamont Strothers was the greatest basketball player in CNU's history and one of the best in Division III history. A three-time All-American, he was selected in the second round of the 1991 NBA draft and later played for both the Portland Trailblazers and Dallas Mavericks. Strothers is still the third leading scorer in Division III history with 2,709 points.

Prof. L. Barron "Barry" Wood Jr. enjoyed a long and distinguished CNU career as both an administrator and faculty member, teaching courses in English and theater. A graduate of Hampden-Sydney College and the University of Pennsylvania, he was among the first group of faculty hired to teach at Christopher Newport in 1961. He retired in 2003 after 42 years of service, possibly the longest faculty tenure in CNU history.

Dr. Harold Cones, shown in 1990, was another highly regarded faculty member. A specialist in environmental science and marine biology, Cones joined Christopher Newport in 1968 and was appointed chairman of the biology, chemistry, and environmental science department in 1980. An award-winning professor, Cones served for several years as the senior faculty member and carrier of the mace before his retirement in 2008.

For several years, Christopher Newport hosted an annual Founders Day celebration, inviting former students, faculty, and staff back to campus for festivities and camaraderie. Shown here are the college's first four presidents gathered behind the ceremonial mace during the 1990 Founders Day. From left to right are H. Westcott Cunningham, Dr. James C. Windsor, Dr. John E. Anderson Jr., and President Santoro. (Courtesy of the Windsor family.)

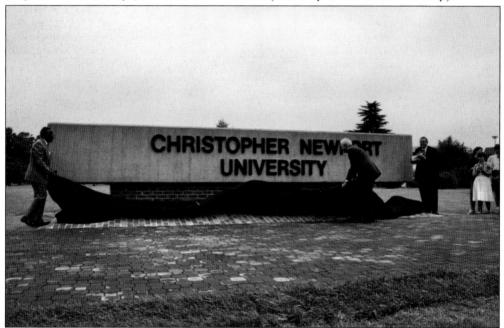

In 1992, Christopher Newport celebrated a major milestone in its history, elevation to university status by virtue of offering master's degree programs. Officials are shown unveiling the institution's new entrance sign. From left to right are Virginia education secretary James W. Dyke Jr., former rector Harrol A. Brauer Jr., and President Santoro.

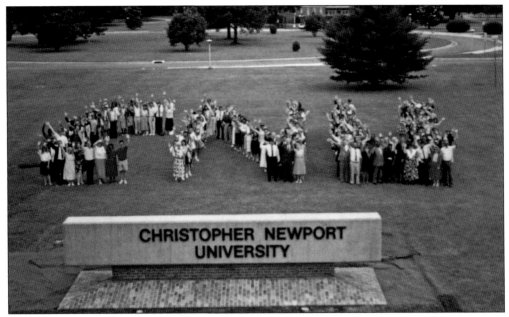

Members of the CNU community also commemorated this historic event by spelling out their new institutional abbreviation for this legendary photograph. Elevation to university status marked an important step in Christopher Newport's institutional evolution. While maintaining its local roots, the university was also beginning to extend its reach to the rest of the state and beyond. (Courtesy of the Santoro family.)

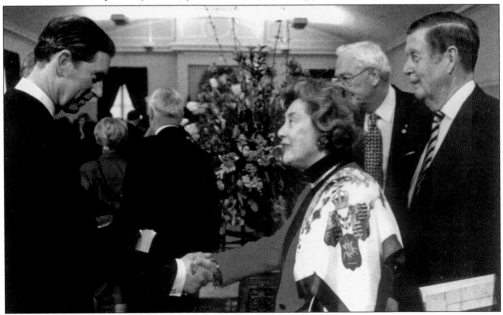

Former president H. Westcott Cunningham and former first lady Cecil Cary Cunningham are shown in 1993 meeting with His Royal Highness the Prince of Wales (left). Prince Charles was in Hampton Roads visiting the College of William and Mary, where he was on hand to help celebrate the 300th anniversary of its founding. (Photograph by Anthony Sylvestro, courtesy of the Cunningham family.)

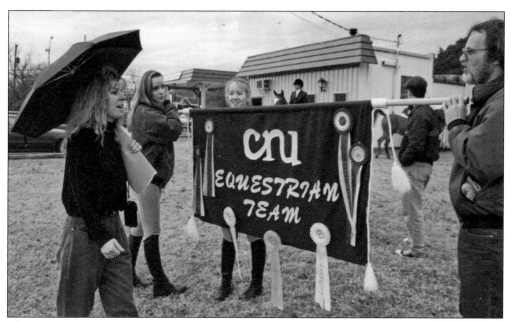

The CNU equestrian team has long been an active component of the university's intramural sports programs. It welcomes all levels of riders and competes with colleges in Virginia and Maryland through the Intercollegiate Horse Show Association. While participating in competitions is important to the team, its main goals are to improve riding skills and cultivate teamwork among members.

The CNU pep band was developed around 1993 to perform at basketball games, open houses, homecoming, and other selected events. Comprised mostly of music majors, the group played various genres ranging from rock to jazz. Several years later, the university also developed a marching band to perform at football games and other campus events.

Scott Scovil is the only CNU athlete outside of track to ever win an individual national championship. As a sophomore, he captured the NCAA Division III national golf championship in 1994. Scovil went on to earn All-American recognition three times and finished seventh in the NCAA event as a senior.

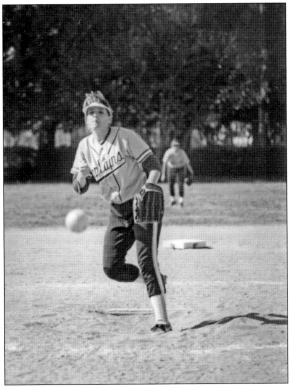

Jill Owens is arguably the greatest softball player in Christopher Newport University history. Shown here in 1995, she was named an All-American in 1998 and was an all-region choice three times. Owens was also a two-time USA South Athletic Conference Player of the Year and a Virginia Division II-III Player of the Year.

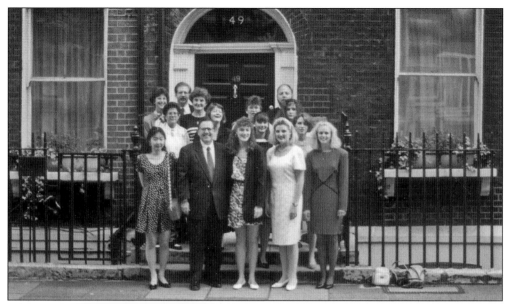

The annual President's Senior Seminar in London was the first foreign study program developed at CNU. President Santoro (first row, second from left) is shown with students in this mid-1990s photograph standing in front of their temporary lodging, Madison House. This particular class studied 18th- and 19th-century British architecture, visiting many historic homes and public buildings, as well as several museums in London. (Courtesy of the Santoro family.)

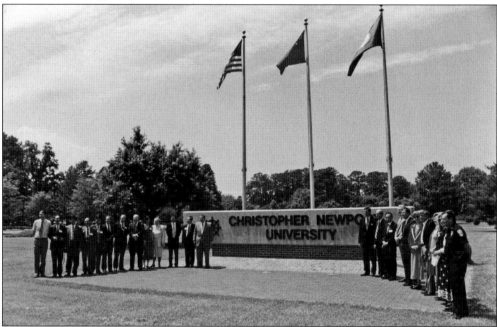

In his efforts to enhance international study programs at CNU, President Santoro developed particularly strong relationships with both Chinese and Japanese authorities. A delegation of Chinese officials visited campus in 1995 and was honored with a ceremonial raising of their national flag at the university's front entrance. (Courtesy of the Santoro family.)

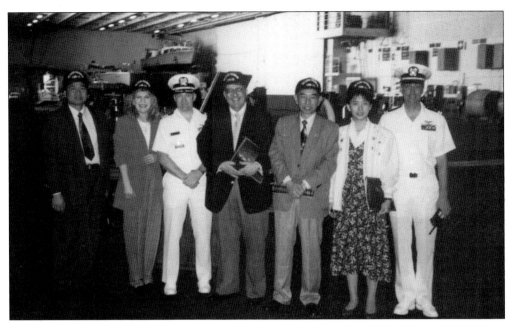

During the Chinese delegation's visit, President Santoro also arranged for a tour of the USS *George Washington*, an aircraft carrier then stationed at the Norfolk navy base. Santoro (fourth from left) is shown with Dr. Song-kai Xie (third from right), president of Foshan University and a member of the National People's Congress, along with U.S. Navy personnel and other members of the delegation. (Courtesy of the Santoro family.)

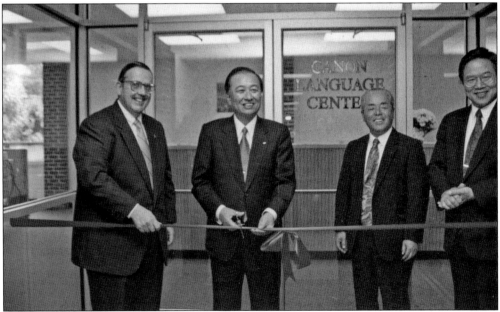

Canon has been a longtime CNU corporate supporter. In the mid-1990s, they supplied the funds and equipment to create a language center in McMurran Hall designed for students to enhance their foreign language competency. President Santoro is shown dedicating the facility with visiting Canon executives. From left to right are Santoro, Dr. Keizo Yamaji, Shin-ichiro Nagashima, and Haruo Murase.

CNU's executive vice president, William L. "Bill" Brauer, is a longtime campus administrator. A 1977 Christopher Newport graduate, Brauer earned an M.B.A. from William and Mary before returning to CNU during the Santoro administration. He plays a lead role in planning and executing campus construction projects and also manages auxiliary services. Brauer is a son of Elizabeth "Skeeter" Brauer and Harrol A. Brauer Jr., Christopher Newport's first rector.

In 1995, the CNU Alumni Society named Shin-ichiro Nagashima as an honorary alumnus, becoming only the second person to win this prestigious award. As chairman and chief executive officer of Canon Virginia, Inc., he was a strong CNU advocate throughout the 1990s. Along with helping to bring the Japanese Tea House and Canon Language Center to campus, Nagashima was also a longtime member of the board of visitors.

An important milestone in CNU's history was the 1994 opening of its first residence hall. For the first time, students could now reside on campus, marking a major step in the development of campus life at the university. While the idea for a residence hall first originated in the late 1970s, President Santoro, with the help of some key state legislators, provided the final push to make it a reality.

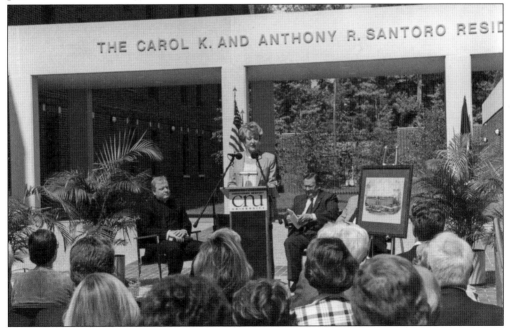

In a June 13, 1995, resolution, the board of visitors named the new residence hall the Carol K. and Anthony R. Santoro Residence Hall to honor the Santoros for their CNU service. Carol Santoro is shown speaking at the September 18, 1995, dedication ceremony. (Courtesy of the Santoro family.)

The addition of a residence hall at CNU allowed students from beyond Hampton Roads to study at the university. Although there were initially few residential students, this precedent laid the foundation for the massive residential population growth in the early 2000s. Shown in the mid-1990s are incoming students participating in freshman orientation.

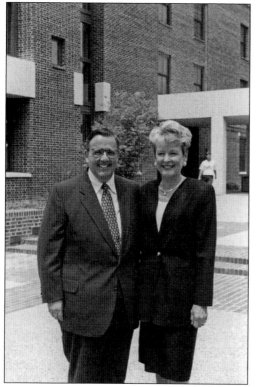

CNU experienced many changes during the Santoro administration, including its elevation to university status, the implementation of master's degree programs, and the development of a student residence facility. Building upon the accomplishments of their predecessors, the Santoros helped prepare the university for the new direction it would take in the years ahead. (Courtesy of the Santoro family.)

Five

A New Direction
1996–2002

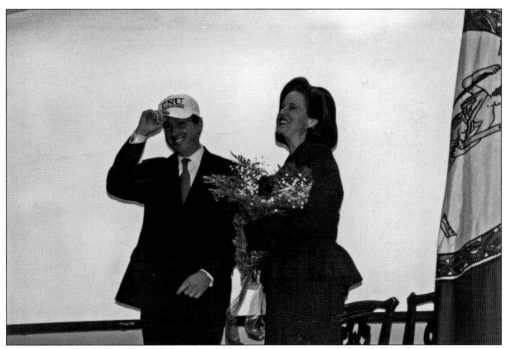

The Honorable Paul S. Trible Jr. was named CNU's fifth president in December 1995, succeeding President Santoro. A former board of visitors member, Trible served on the presidential search committee earlier that year but was later offered the position personally. "We both saw CNU as a potential jewel," Rosemary Trible, Paul's wife, later recalled. "We felt and hoped we could make a difference, polish that jewel, and make it a great university."

The Honorable Paul S. Trible Jr. became Christopher Newport University's fifth president in January 1996. Born in Baltimore, Maryland, Trible earned his bachelor's degree from Hampden-Sydney College, followed by a law degree from Washington and Lee University. After working as a federal prosecutor, he settled in his family's ancestral home area of Virginia's Northern Neck and was appointed Essex County Commonwealth's attorney in 1974. Two years later, Trible continued his rapid political ascent by winning election to the U.S. House of Representatives. In 1982, he was elected to the U.S. Senate, winning a close race to replace retiring senator Harry F. Byrd Jr. As a senator, Trible was best known for his work investigating the Iran-Contra scandal in 1986. Declining to seek a second term in 1988, he served instead on the American delegation to the United Nations and taught at Harvard shortly thereafter. After an unsuccessful gubernatorial run in 1989, Trible ran a governmental consulting firm and served on CNU's board of visitors before his appointment as president. (Photograph by Ian Bradshaw.)

First Lady Rosemary D. Trible and her husband are full partners in encouraging excellence among young people through education. Born in Little Rock, Arkansas, Rosemary was selected America's Junior Miss in 1967 and later graduated from the University of Texas. After working on Capitol Hill for U.S. senator John McClellan of Arkansas, she hosted a Richmond, Virginia–based television talk show called *Rosemary's Guestbook* until her husband was elected to Congress. In 1978, she founded an international import company and was later vice president of an interior design firm in Washington, D.C. Trible is also known for her humanitarian work and volunteerism. For three years, she worked with International Cooperating Ministries, helping to build churches in such places as Cuba, Vietnam, and China. Trible was also involved with Mother Teresa and her Sisters of Charity in India. At CNU, she plays an active role on campus and leads two women's Bible study groups for students. (Photograph by Ian Bradshaw.)

David Peebles (right) has been a longtime CNU supporter, contributing generous amounts of time and financial resources to the university. A former president and chairman of Ferguson Enterprises, Peebles served as a member of the board of visitors for eight years and was rector during the mid-1990s. He also played a key role in securing initial funding for the Ferguson Center for the Arts.

For several years, CNU students and faculty members have enjoyed a close association with the nearby NASA–Langley Research Center in Hampton, Virginia. Working with NASA scientists, they conduct groundbreaking research in several scientific areas on a regular basis. CNU professors Dr. C. Ken Chang (left) and Dr. Martin Buoncristiani are shown at NASA–Langley's main entrance in this late-1990s photograph.

The Honorable Donald T. Regan (right) was Christopher Newport's 1997 commencement speaker. A Massachusetts native and World War II combat veteran, Regan enjoyed a distinguished career in business and government. He worked for Merrill Lynch and Company, Inc., for more than 30 years, eventually becoming its chief executive officer. From 1981 to 1985, Regan served as the U.S. treasury secretary and was later U.S. president Ronald Reagan's chief of staff.

Dr. Susan St. Onge, a distinguished professor of French, is one of CNU's most well known and distinguished faculty members. She joined the Christopher Newport faculty in 1970 and was a recipient of the Outstanding Faculty Award from the State Council of Higher Education for Virginia in 1997. She is shown with Gov. George Allen in this 1997 photograph.

The Ella Fitzgerald Music Festival began in 1998 as an educational outreach program designed to honor jazz icon and Newport News native Ella Fitzgerald. Sponsored by CNU and the City of Newport News, legendary jazz artists, including Branford Marsalis, Natalie Cole, Chick Corea, and Arturo Sandoval, have performed at this annual event over the years.

Prof. William "Bill" Brown, CNU's director of jazz studies since 1997, is shown performing with members of the university's jazz ensemble. The jazz program is highly regarded in the music community and performs regularly on campus and around the world. It also performs annually at the Ella Fitzgerald Music Festival as one of the highlights of that program.

Athletic director C. J. Woollum has enjoyed a long and distinguished career at CNU. Besides leading the university's athletics program since 1987, he has served as head coach of the successful men's basketball team since 1984, averaging 20.2 wins per year and compiling a winning percentage of more than .721. In the 1990s, he also coached the men's golf team, which earned several NCAA tournament bids during his tenure.

Since joining CNU in 1999, Dr. Donna Mottilla has played a major role in enhancing the university's business programs. As dean of the business school, she led the effort that culminated in earning accreditation from the Association to Advance Collegiate Schools of Business (AACSB) in 2005. After concluding her service as dean in 2007, she returned to the CNU faculty, where she now serves as a professor of management.

Dean of admissions Patricia "Patty" Patten (standing) has played a prominent role in CNU's recent history. Her hard work has helped generate significant increases in university application rates, standardized test scores, and incoming student grade point averages. She joined Christopher Newport in August 1997 after serving as admissions director at two other institutions. Patten is pictured in this late-1990s photograph with a prospective student and parent.

Vice president for student services Maurice J. "Maury" O'Connell is another integral official at CNU. A former U.S. Air Force officer and Vietnam veteran, O'Connell served previously as the dean of students. Prior to joining Christopher Newport, he was a higher education consultant and longtime administrator at American University, where he served as vice-provost for student life. At CNU, O'Connell's responsibilities include student services, admissions, financial aid, and campus police.

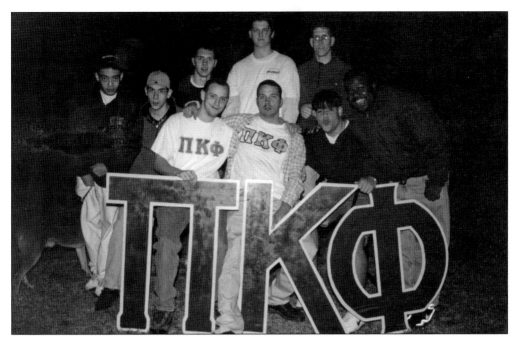

In recent years, CNU has developed a thriving Greek life on campus. Approximately 12 percent of undergraduates belong to a fraternity or sorority. Members of Pi Kappa Phi are shown in this 1999 photograph. The other campus fraternities include Kappa Delta Rho, Pi Lambda Phi, Sigma Tau Gamma, Sigma Phi Epsilon, Tau Delta Phi, and Phi Beta Sigma.

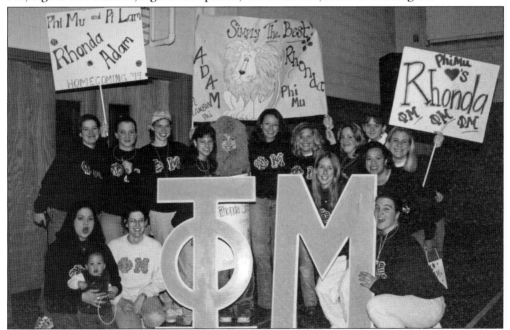

There are also several active sorority chapters on campus, including the members of Phi Mu, shown here. Students administer Greek life at CNU, supported by a full-time professional staff member. The other sororities on campus include Alpha Phi, Alpha Sigma Alpha, Gamma Phi Beta, Zeta Tau Alpha, Alpha Kappa Alpha, and Delta Sigma Theta.

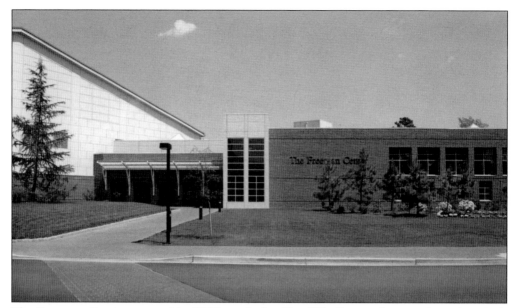

The Freeman Center opened in 2000, replacing Ratcliffe Gymnasium as the university's primary athletic facility. It includes a 200-meter indoor track, three basketball courts, a café, administrative offices, and 10,000 square feet of workout space. The facility also houses the Trieshmann Health and Fitness Pavilion, named in honor of longtime CNU supporters Dr. H. W. "Chip" and Sarah Trieshmann. An addition to the building is scheduled to open in the summer of 2010.

The Freeman Center is named to honor the leadership and generosity of Peninsula businessman Robert L. Freeman Sr. and his family. In 1998, they donated $1 million toward the construction of the Ferguson Center for the Arts. Freeman is shown here with his wife, Dorothy. Their son, Robert L. Freeman Jr., is a former rector of the board of visitors. (Photograph by Olan Mills Studios, courtesy of the Freeman family.)

Before touring buildings or interacting with students and faculty, visitors often remark on the campus's beautiful flowers and landscaping. It is the job of the CNU grounds department to create this positive first impression for guests. Through their hard work, the groundskeepers create and maintain a welcoming environment for the entire campus community.

The Virginia Electronic Technology Center (VECTEC) was established at CNU in 1994 as the university's economic development outreach program. It enables small businesses to expand their electronic commerce by providing Web design consultation, educational seminars, and research assistance. Shown in this 2000 photograph are Dr. William Winter (left), VECTEC's founder and first chairman, and VECTEC director William Muir.

For many years, CNU has enjoyed a vibrant music program. In addition to several instrumental groups, the university offers many active choral programs, led by Dr. Lauren Fowler-Calisto. These talented groups include a men's chorus, a women's chorus, and a chamber ensemble. A choral ensemble dressed in their performance attire is shown in this early-2000s photograph.

In 2000, CNU officials decided to redevelop the center of campus with a fountain that has become another CNU landmark. The centerpiece of this renovation was a bronze sculpture depicting Canada geese in flight created by sculptor David Turner and donated by longtime CNU supporters William "Bill" and Tudie Saunders. This scenic area was named Saunders Plaza in recognition of their contribution.

In recent years, graduating CNU students have followed a tradition of throwing pennies. During freshman orientation, incoming students are each given a penny to keep for good luck. As they conclude their college careers, the students are then encouraged to throw their penny in the Saunders Plaza fountain as they process to their commencement ceremony.

Dr. Robert E. Colvin (second from left) and Dr. Quentin Kidd (third from left) are two of CNU's most popular and respected faculty members. Shown in 2000, Dr. Colvin chairs the department of leadership and American studies, specializing in leadership studies. Dr. Kidd chairs the government department and directs the CNU Center for Public Policy.

Former U.S. president George H. W. Bush visited CNU in 2000 to campaign for his son, Texas governor George W. Bush, then the Republican nominee for president. Bush gave a brief speech before he toured campus and met with students and campus officials, including President Trible, who served in the U.S. Senate when Bush was vice president.

First Lady Rosemary Trible is shown congratulating a student at an early-2000s commencement ceremony. Like her husband, Trible takes great pride in CNU's students and interacts with many of them during their time on campus. At each commencement, she has made it her custom to assist all of the graduating students off stage after receiving their diplomas in order to congratulate them personally.

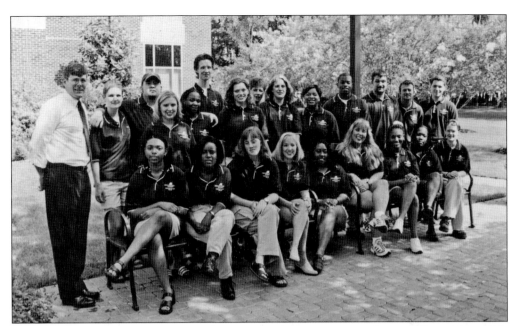

As the residential student population has increased in recent years, the need for residence life staff has also grown. Student resident assistants (RAs) and front desk assistants (FDAs) now regularly augment the full-time professional staff and play a key role in the effective operation of the university's main-campus residence halls. Then–dean of students Maurice J. "Maury" O'Connell is shown in this early-2000s photograph with a group of resident assistants.

Opened in 2000, James River Hall was the second residence hall constructed on the Christopher Newport campus. Equipped with large suites to accommodate multiple students, James River houses mostly sophomores and juniors. It also contains themed units for campus organizations such as fraternities and sororities. In addition to student housing, James River Hall contains the campus health center.

Lindsay Sheppard Birch (second from right) is one of CNU's most accomplished volleyball players. Named Player of the Year in the old Dixie Conference, she led her team to the school's first-ever NCAA appearance in 2001. The next year, she was named the team's head coach, guiding it to another conference title and NCAA appearance.

Antoine Sinclair is one of the top players in modern CNU basketball history. He was the only senior on the Captains' 2000–2001 team, and he was the only one to ever win four consecutive Dixie Conference championships. Sinclair was also a two-time All-American and is the fourth leading scorer in CNU history (1,736 points) and second leading rebounder (1,031).

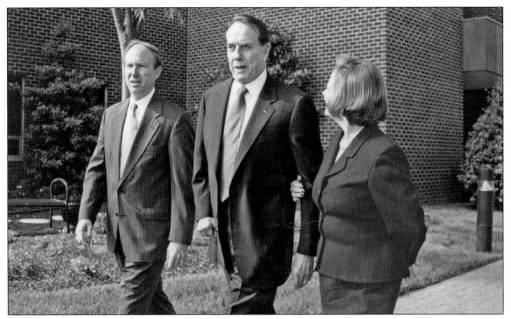

The Honorable Robert. J. "Bob" Dole (center) was Christopher Newport's 2001 commencement speaker. A Kansas native and World War II combat veteran, Dole served in the U.S. Senate from 1969 to 1996, where he led the Republican caucus for several years. He was also the Republican Party's 1976 vice-presidential candidate and 1996 presidential candidate. Senator Dole is shown here touring campus with the Tribles.

Award winning singer-songwriter Alicia Keys performed at CNU during homecoming in October 2001. The concert occurred only a few months after the release of her debut album, *Songs in a Minor*, which would go on to earn five Grammy Awards. In recent years, Keys has achieved phenomenal success, selling more than 25 million albums worldwide as of 2007.

After taking ownership of the old Ferguson High School in 1996, CNU officials envisioned using it to build a world-class performing arts center. Shown here is a rendering of the proposed facility designed by I. M. Pei, a renowned architect whose other designs include the John F. Kennedy Presidential Library in Boston, the Bank of China Tower in Hong Kong, and the Pyramids of the Louvre in Paris.

In the spring of 2002, CNU broke ground on the Ferguson Center for the Arts. Upon completion, the facility would become home to CNU's many performing arts programs. It would also provide people from across the region access to nationally and internationally known entertainers. The Tribles are shown signing their names into the wet foundation cement.

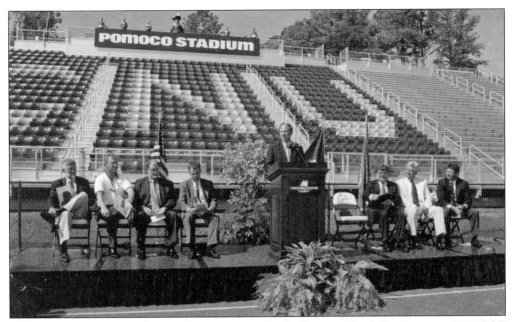

In 2001, CNU built a stadium to house its new football team. The following year, POMOCO Automotive Group secured the naming rights in a $1-million deal. President Trible is shown speaking at the September 2002 dedication ceremony for the newly renamed POMOCO Stadium. In 2003, the facility was expanded with the addition of a brick facade, permanent concession stands, a press box, and other amenities.

Matt Kelchner, who was named CNU's head football coach in 2000, has guided the Captains to five NCAA playoff berths and winning seasons in each of the first seven years of the university's football history. Under Kelchner's leadership, CNU reached the NCAA playoffs in its first four seasons, the only school in college football history ever to accomplish that feat.

Since CNU is a community of honor, incoming students are required to sign an honor code. This code states, "On my honor, I will maintain the highest possible standards of honesty, integrity and personal responsibility. That means I will not lie, cheat, or steal and as a member of this academic community, I am committed to creating an environment of respect and mutual trust."

CNU students gather in this 2002 photograph to commemorate the first anniversary of the September 11, 2001, terrorist attacks on the World Trade Center and the Pentagon. The impact of the September 11 tragedy was felt by many members of the campus community. They supported and grieved with CNU students who were affected directly by the attacks.

Six

CNU TODAY
AND TOMORROW
2003–2008

The modern CNU campus is in an exciting era of growth and change. To better accommodate its majority residential student population, the university has built several new facilities, including the Trible Library (left), the David Student Union (right), and York River residence hall (background). Construction will continue during the next several years as the university continues to evolve. (Photograph by Caitlin Dana.)

The CNU Honors Program provides an enriched educational experience for academically talented students motivated to participate in challenging courses and cultural and intellectual activities. Honors students are eligible for scholarships, research grants, and overseas study opportunities. President Trible and his wife, Rosemary, are shown here with Amanda Wright, a 2003 Honors Program graduate.

The President's Leadership Program (PLP) plays an important role in fulfilling CNU's mission of promoting leadership, civic engagement, and honor among its students. PLP students are selected competitively and receive scholarships and funding for overseas study. In return, they minor in leadership studies and pursue extensive volunteer service in the outside community. PLP students are photographed here climbing a tower during the annual leadership adventure program. (Photograph by Doug Buerlein.)

In recent years, a major accomplishment for CNU has been a rapid increase in its instructional faculty, rising from about 107 in the mid-1990s to almost 240 in 2007. This ongoing faculty growth allows the university to keep its class sizes small and provides students with a wide variety of course options and other educational opportunities. CNU faculty members are shown here processing with bagpipers to commencement.

Judy Ford Wason has enjoyed a close affiliation with CNU for several years. A well-known political activist who managed campaigns for several of Virginia's high-profile elected officials, Wason was a special assistant to U.S. president Ronald Reagan in the early 1980s. After serving on the board of visitors in the early 2000s, she was CNU's vice president for institutional advancement before retiring in 2007. (Photograph by Ian Bradshaw.)

In 2003, CNU achieved its greatest baseball season ever, reaching the national championship game as part of a 35-9 season. Leading the way were three players later chosen as All-Americans. Shown here (from left to right) are head coach John Harvell, third baseman Chris Phaup, center fielder Jeremy Elliott, and right fielder Matt Turner.

Nathan Davis is photographed catching a touchdown pass from Phillip Jones in the end zone with 3:03 remaining to give CNU a 24-20 victory over Muhlenberg College in CNU's first-ever NCAA football playoff win on November 22, 2003. CNU was the first team in college football history to reach post-season play within its first four years of existence.

CNU's field hockey team is shown celebrating its 5-1 victory over Alvernia College in the first NCAA game in program history in 2006. Within only seven years of existence, the team reached the Elite Eight round of the NCAA event en route to a 14-4 record. Coach Carrie Moura was later named National Coach of the Year by womensfieldhockey.com.

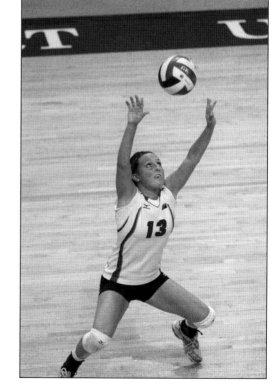

Brittany Collins is considered one of the finest volleyball players in CNU history. She was a two-time All-American (2006–2007), a two-time USA South Athletic Conference Player of the Year, and a three-time Most Valuable Player of the conference tournament. Collins completed her career with a total of 5,103 assists, among the top figures in Division III history.

In recent years, the CNU cheerleading squad has achieved national prominence under the direction of head coach and CNU alumna Erica Flanigan. In February 2008, the team won the USA South Cheerleading Championship, held in Fayetteville, North Carolina. It also placed second and third, respectively, at the 2007 and 2008 national championships. (Photograph by Van White.)

Coached by Christopher "Chris" Swanenburg, men's lacrosse is the newest athletic team at CNU. Christopher "Chris" Quigley (shown here) scored the first goal in the team's history when he tallied at 14:16 of the first quarter against Marymount College in CNU's inaugural men's lacrosse game on February 25, 2007. The Captains won the game 9-8.

President Trible is shown with one of CNU's core supporters, Newport News physician and businesswoman Dr. Sarah Forbes. In 2006, Dr. Forbes provided CNU with a $1-million gift to its Endowed Merit Scholarship Challenge Campaign, providing a dollar-for-dollar match for other gifts over the next five years. The endowed scholarship issues annual awards to academically talented students. (Photograph by Ian Bradshaw.)

Photographed here with the Tribles, Newport News mayor Joe S. Frank (second from left) and his wife, Jane Susan Frank (second from right), are both enthusiastic CNU supporters. First elected in 1996, Mayor Frank has been instrumental in supporting the university's rapid physical growth. Jane Susan Frank, a member of the board of visitors, is also an active presence on campus. (Photograph by Doug Buerlein.)

The Reverend Dr. Ralph Waller was CNU's 2005 commencement speaker. Dr. Waller serves as the principal of Harris Manchester College, one of the constituent colleges comprising the University of Oxford in the United Kingdom. CNU is closely affiliated with Harris Manchester, sending students there for both study abroad coursework and for its annual Oxford Seminar, a program that prepares CNU students to apply for highly competitive post-graduate scholarships.

Gov. Timothy M. Kaine was CNU's 2008 commencement speaker. A Missouri native and Harvard Law School graduate, Kaine was mayor of Richmond and later Virginia's lieutenant governor before running a successful campaign for governor in 2005. He is also a son-in-law of former governor A. Linwood Holton Jr. (Photograph by Doug Buerlein.)

The Honorable Kathleen Kennedy Townsend (right) is shown here with President Trible and CNU's director of planned giving, Lucy Latchum. The eldest child of Robert F. Kennedy and a former Justice Department official, Townsend served as lieutenant governor of Maryland from 1995 to 2003. She came to CNU in 2007 to give the keynote address for the university's annual convocation ceremony.

In February 2008, France's ambassador to the United States, Pierre Vimont (left), visited campus to speak at a special dinner cosponsored by the World Affairs Council of Greater Hampton Roads. Ambassador Vimont is shown here meeting with student Lacey Grey Howard as event organizers Dr. Mario Mazzarella (second from left) and Dr. Anthony R. Santoro, president emeritus (second from right), look on. (Photograph by Doug Buerlein.)

In 2004, Christopher Newport University created a marching band in order to expand its successful music programs. Led by director of athletic bands Brantley T. Douglas III, the organization has achieved prominence among Virginia's collegiate marching bands. It was even selected to perform in the televised 2008 Philadelphia Thanksgiving Day Parade. The Marching Captains are shown here performing at a CNU football game in 2007.

Written by CNU theater professor Steven Breese, *Actus Fidei* (Latin for "An Act of Faith") premiered at the Ferguson Center in March 2007 as part of the Jamestown 2007 Commemoration. Inspired by the life and times of Capt. Christopher Newport, the play traveled backward through time to confront the heroes and anti-heroes who shaped our world 400 years ago. Broadway veteran John Michalski (third from left) portrayed Captain Newport.

In recent years, there has been a significant increase in the number of study abroad opportunities for CNU students, with courses now offered in such places as China, Morocco, France, and at CNU's study center in Prague, Czech Republic. A group of students and faculty were photographed in July 2007 outside of the Churchill Museum and Cabinet War Rooms in London, England. (Courtesy of the Trible family.)

Award-winning English professor Dr. Douglas Gordon (center) enjoyed an accomplished record of service throughout his nearly 30-year career at CNU. Known affectionately as "Dr. Dog" for his essays on dogs in literature, he was appointed dean of the College of Liberal Arts and Sciences in 2003 after a successful faculty career. As dean, he oversaw a major increase in faculty development before his retirement in 2009. (Photograph by Doug Buerlein.)

One of CNU's most accomplished academic leaders was Dr. Richard M. "Dick" Summerville. A mathematician, he joined the CNU faculty in 1980, serving first as a dean and later as vice president for academic affairs. Summerville then served as provost for several years before his retirement in 2007. The Summerville Reading Room in the Trible Library is named in his honor. (Photograph by Doug Buerlein.)

Dr. Mark W. Padilla, photographed here at a recent commencement ceremony, is CNU's current provost. Appointed in 2007, Padilla has an extensive background in higher education leadership, having served previously in high-level administrative positions at both the University of North Carolina–Asheville and Bucknell University. As a teacher and scholar, he specializes in classical studies and has many scholarly publications to his credit. (Photograph by Doug Buerlein.)

Claude A. "Chip" Hornsby III is group chief executive of Wolseley PLC and the current rector of CNU's board of visitors. A former president and chief executive officer of Ferguson Enterprises and a longtime CNU supporter, Hornsby was instrumental in securing funding for construction of the Ferguson Center of the Arts. (Photograph by Doug Buerlein.)

James R. "Jay" Joseph is a senior director for local real estate firm GVA Advantis and the current vice-rector of CNU's board of visitors. A graduate of both Harvard University and the University of Pennsylvania's Wharton School, Joseph participates regularly in meetings, ceremonies, and other campus events. His sister, the Honorable Molly Joseph Ward, is mayor of Hampton, Virginia. (Photograph by Doug Buerlein.)

For several years, Delegate Phillip "Phil" Hamilton (left) has been one of CNU's most active legislative supporters. A Newport News resident first elected to the Virginia House of Delegates in 1988, he has secured vital state appropriations for the university and is also active in campus activities. Hamilton is shown in this 2008 photograph with President Trible (center) and Gov. Timothy Kaine. (Photograph by Doug Buerlein.)

Sen. John Miller (left) is another key CNU supporter serving in the Virginia General Assembly. A longtime television reporter, he also served as a legislative aide to then–U.S. senator Paul Trible and later was CNU's vice president for university relations before winning election to the Virginia Senate in 2007. Along with his Senate duties, Miller remains an important part of the CNU community, serving as associate director of VECTEC.

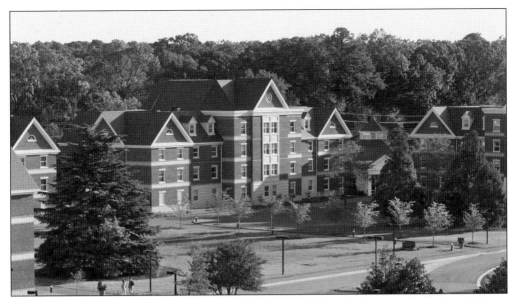

York River residence hall opened in 2002, continuing CNU's movement toward a majority residential campus. Consisting of two distinct buildings with separate lobbies, each room in this complex is approximately 200 square feet and is normally shared by two or three students. Like Santoro Hall, York River Hall is designed to house freshmen.

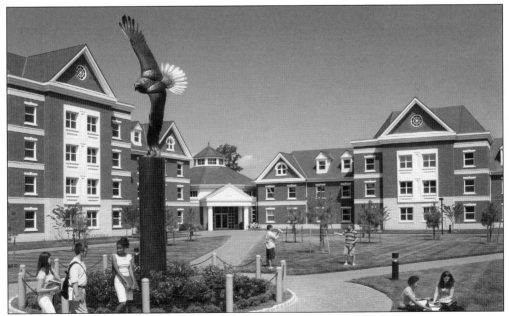

The $18-million Potomac River residence hall opened in 2004. Like James River Hall, it is designed with large suites to accommodate mostly sophomores and juniors. Potomac River Hall is currently the newest residence facility on the main campus. However, university officials plan to build a future residential village, a series of houses joined by a colonnade, between Santoro Hall and the Freeman Center.

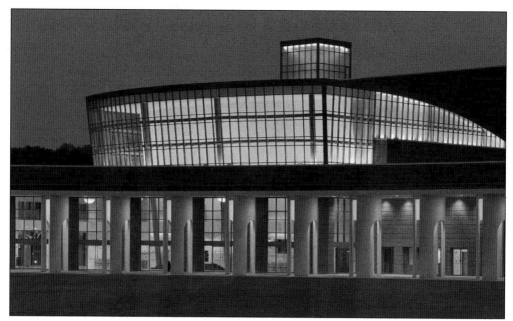

The first component of the Ferguson Center for the Arts opened in 2004. Designed in the high modernist architectural style, the building includes three concert halls, a wide variety of classrooms, rehearsal rooms, prop and costume shops, and a dance studio. It is named to honor Ferguson Enterprises, which played a major role in financing its construction. (Photograph by Robert Benson.)

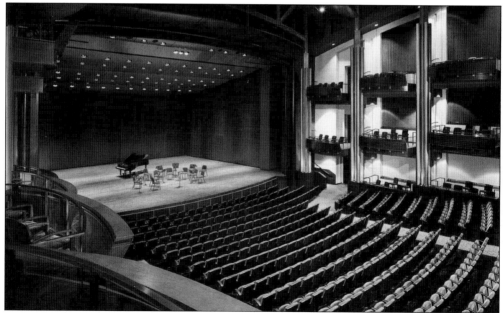

The centerpiece of the Ferguson Center is its grand concert hall, which seats 1,725 people. It opened in the fall of 2005 with a performance by singer and actor Michael Crawford, who was accompanied by the New York Pops. A long list of world-class entertainment has since performed at this venue, ranging from Broadway to ballet and international orchestras to comedians. (Photograph by Robert Benson.)

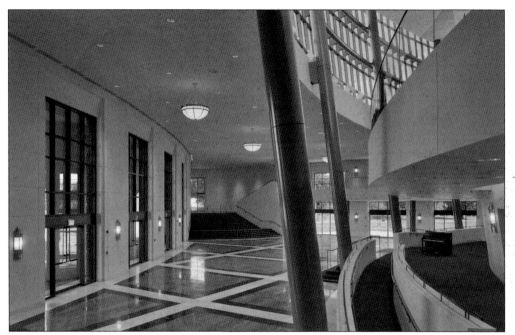

The beautiful marble lobby outside of the grand concert hall is an elegant space used for dinners and other important campus gatherings. It is often adorned with playbills featuring upcoming performances in the grand concert hall. There are also meeting rooms located near the lobby that are used for receptions and parties. (Photograph by Robert Benson.)

The Ferguson Center has another attractive lobby (shown here) in front of its 453-seat music and theater hall. This venue opened in the fall of 2004 featuring a concert by renowned singer Tony Bennett. Impressed by the facility's acoustic quality during his performance, Bennett remarked, "They don't make theaters like this anymore!" (Photograph by Robert Benson.)

In recent years, CNU officials have focused on the development of the "east campus," separated from the main campus by Warwick Boulevard. The CNU Apartments opened in 2002, followed by the CNU Village (shown here) in 2005. Both facilities are designed for upperclassmen, offering individual bedrooms and bathrooms. The CNU Village also houses several commercially owned restaurants and businesses, all utilized extensively by outside community members and CNU students, faculty, and staff.

The 116,000-square-foot, three-story David Student Union (DSU) opened in 2006, replacing the smaller student center, which was demolished in early 2008. Featuring a stately neo-Georgian–style architecture, the building was named by longtime CNU supporter Edward D. "Buddy" David and his siblings in honor of their parents, William and Goldie David. (Photograph by Ian Bradshaw.)

The DSU features a wide array of student and administrative offices, conference rooms, and dining facilities. Described as the heartbeat of the campus, it also contains the university bookstore, student game rooms, and a post office. Students are shown walking through the DSU's "main street" corridor. (Photograph by Ian Bradshaw.)

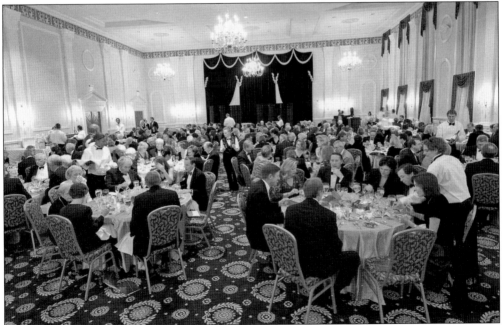

One of the most impressive sections of the David Student Union is the elegant ballroom, located on the building's second floor. Ornately decorated, it is used extensively for meetings, parties, conferences, dinners, and other special events. Guests are photographed here enjoying a formal dinner in the ballroom. (Photograph by Doug Buerlein.)

The Paul and Rosemary Trible Library opened in early 2008, replacing the Captain John Smith Library, which was incorporated into this newer building. The board of visitors named the library after the Tribles in honor of their many contributions to the university. With a 14-story cupola marking the center of campus, the 110,000-square-foot facility has quickly become a vibrant center for research and study. (Photograph by Hunter Bristow.)

Containing more than 400,000 volumes, the Trible Library is equipped with several computer stations, a media center, study areas, and the elegant Blechman and Summerville reading rooms. The building also houses the world-renowned Mariners' Museum library collections. Students are shown visiting in the library's front lobby. (Photograph by Ian Bradshaw.)

The Trible Library was dedicated on January 24, 2008, during a well-attended campus-wide celebration. Along with performances from a student string ensemble and the women's chorus (shown here), the event culminated with an outdoor performance by the CNU pep band, followed by a spectacular fireworks display. (Photograph by Doug Buerlein.)

Located in the Trible Library, Einstein's is a popular university-operated bakery and coffee shop. Along with sandwiches and pastries, the café serves a wide variety of coffees, cappuccinos, espressos, and milkshakes, which are quite popular among members of the CNU community. Manager Lisa Taliafero (second from right) is photographed with some of her student employees. (Photograph by Doug Buerlein.)

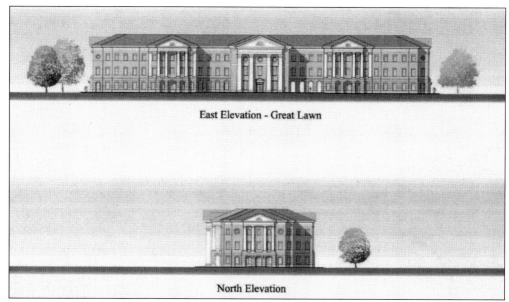

East Elevation - Great Lawn

North Elevation

The new Lewis Archer McMurran Jr. Hall is currently under construction to provide much-need classroom and office space. Located on the site of the old student center, this approximately 82,000-square-foot facility will replace the original McMurran Hall and will house most of the university's humanities and social sciences departments. Designed to include 30 state-of-the-art classrooms and more than 120 faculty offices, this building is scheduled to open in the fall of 2009.

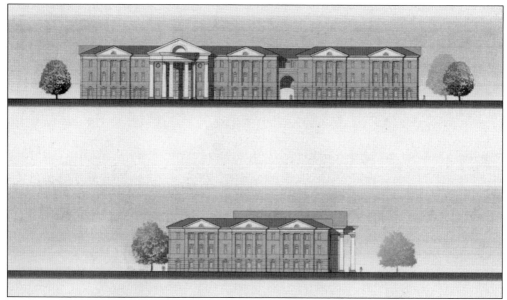

A new 114,000-square-foot integrated science center, designed to replace Gosnold Hall and incorporate parts of the Science Building, is currently being designed. The facility will house the university's science departments and include 60 faculty offices, 10 classrooms, and 70 new teaching and research labs. The new building is scheduled for completion in the spring of 2011, with the renovations to the existing Science Building set for completion in the spring of 2012.

Concurrent with the construction of the Ferguson Center of the Arts, Shoe Lane was rerouted to better accommodate the new fine arts facility. The Avenue of the Arts, located behind the Ferguson Center, is now the university's main entranceway, providing a scenic parkway to the campus and the residential neighborhoods behind it. (Photograph by Hunter Bristow.)

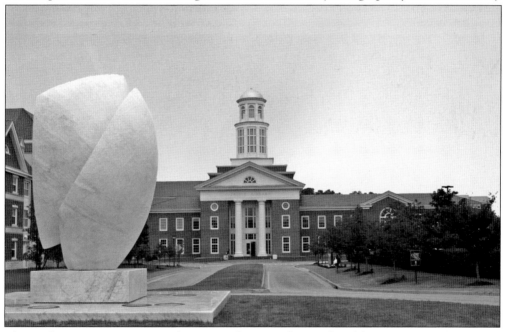

Christopher Newport University has come a long way from its humble origins in an abandoned high school. It now enjoys world-class facilities and an attractive, scenic campus. In the fall of 2008, CNU's main entranceway was enhanced with a 38,000-pound Italian marble sculpture called Elements created by Norwegian artist Inger Sannes. The sculpture was commissioned by CNU along with the Newport News Public Art Foundation. (Photograph by Caitlin Dana.)

ACROSS AMERICA, PEOPLE ARE DISCOVERING SOMETHING WONDERFUL. *THEIR HERITAGE.*

Arcadia Publishing is the leading local history publisher in the United States. With more than 4,000 titles in print and hundreds of new titles released every year, Arcadia has extensive specialized experience chronicling the history of communities and celebrating America's hidden stories, bringing to life the people, places, and events from the past. To discover the history of other communities across the nation, please visit:

www.arcadiapublishing.com

Customized search tools allow you to find regional history books about the town where you grew up, the cities where your friends and family live, the town where your parents met, or even that retirement spot you've been dreaming about.